NEWCASTLE UPON TYNE

THE POSTCARD COLLECTION

ALAN SPREE

AMBERLEY

First published 2023

Amberley Publishing
The Hill, Stroud, Gloucestershire, GL5 4EP
www.amberley-books.com

Copyright © Alan Spree, 2023

The right of Alan Spree to be identified as the
Author of this work has been asserted in accordance with
the Copyrights, Designs and Patents Act 1988.

ISBN 978 1 3981 1499 9 (print)
ISBN 978 1 3981 1500 2 (ebook)

British Library Cataloguing in Publication Data.
A catalogue record for this book is available from the
British Library.

Origination by Amberley Publishing.
Printed in Great Britain.

CONTENTS

SHORT HISTORY OF NEWCASTLE TO THE 1950s

The history of Newcastle dates from AD 122, when the Romans built the first bridge to cross the River Tyne at that point. The bridge was called Pons Aelius or 'Bridge of Aelius', Aelius being the family name of Roman Emperor Hadrian. The Tyne was then a wider, shallower river at this point and it is thought that the bridge was probably about 700 feet long, made of wood and supported on stone piers. It is probable that it was sited near the current Swing Bridge.

The Romans built a stone-walled fort in AD 150 to protect the river crossing, that was at the foot of the Tyne Gorge, and this took the name of the bridge so that the whole settlement was known as Pons Aelius. The fort was situated on a rocky outcrop overlooking the new bridge, on the site of the present castle keep.

The Angles arrived in the north-east of England in about 500 and may have landed on the Tyne. There is no evidence of an Anglo-Saxon settlement on or near the site of Pons Aelius during the Anglo-Saxon age. The bridge probably survived and there may well have been a small village at the northern end, but no evidence survives.

It was under Norman rule in 1080 that the city gained its current name. The 'New Castle', which gave the town its name, was founded in 1080 by the eldest son of William the Conqueror. It was a wooden fort to safeguard the Tyne crossing. A small town then grew up in the area around the new castle.

Throughout the Middle Ages, Newcastle was England's northern fortress. The border wars against Scotland lasted intermittently for several centuries. For a period from 1139 to 1157, Newcastle was effectively in Scottish hands. It is believed that during this period the church of St Andrew and the Benedictine nunnery were built. Henry II took back the Earldom of Northumbria and it returned to English rule. The stone castle keep was built by Henry II between 1172 and 1177. The main gatehouse, known as the Black Gate, was built by Henry III between 1247 and 1250.

The earliest known charter was dated 1175 in the reign of Henry II, giving the townspeople some control over their town. In 1216, King John granted Newcastle a mayor and also allowed the formation of guilds, of which there were twelve initially.

Coal was being exported from Newcastle by 1250, and by 1350 the burgesses received a royal licence to export coal.

Newcastle remained a stronghold against invasions from the Scots during the Middle Ages. This was helped by the 25-foot-high defensive stone wall that was erected in the thirteenth and fourteenth centuries to encircle the town. There were seven main gates and nineteen towers.

Medieval Newcastle prospered partly because of the wars between the English and the Scots. There was much traffic through Newcastle and travellers spent money there.

Around the year 1200, many jetties were starting to project into the river. By 1275, Newcastle was the sixth largest wool-exporting port in England. The principal exports at this time were wool, timber, coal, millstones, dairy produce, fish, salt and hides. Most of the Newcastle merchants were situated near the river, below the castle.

Newcastle also had a shipbuilding industry in the later Middle Ages. The first record of a ship being built there was in 1294. There was also a rope-making industry and a leather industry employing skinners, tanners and saddlers. Other trades included butchers, bakers, brewers, and smiths.

There were two fairs in Newcastle. Fairs were like markets but they were held only once a year and they would attract buyers from all over Northumberland and Durham.

There were four churches in Newcastle. From the thirteenth century, there were also friars and a Benedictine nunnery in Nun Street. There were also several 'hospitals' run by the church in Newcastle. In them, monks cared for the sick and the poor as best they could.

In 1539, Henry VIII closed the friaries in Newcastle, and in 1540, he closed the nunnery. However, Henry also founded a grammar school in Newcastle, which was incorporated in 1600.

In the sixteenth century, exports of coal boomed, and it overtook wool as the town's main export. It is estimated that in 1500 about 15,000 tons of coal were exported from Newcastle each year.

By 1600 the population of Newcastle had risen to around 10,000. In 1642, the civil war between the king and parliament started. Newcastle sided with the king but in 1644 a parliamentary army laid siege to the town. Newcastle surrendered in October 1644.

In 1658, a new guildhall was built and in 1681 the Hospital of the Holy Jesus, which was an almshouse, was also built.

In the late seventeenth century coal exports continued to boom, and so did the shipbuilding industry. Rope making also flourished. Lime was made in kilns for fertiliser. Salt was made from seawater. The water was heated in pans to evaporate it and leave behind a residue of salt. From the late seventeenth century there was a glass making industry in Newcastle. By the early eighteenth century, there was also an iron and steel industry. Another industry in Newcastle was clay pipe making.

In 1711, Newcastle gained its first newspaper. In 1736 an assembly room was built where balls were held and card games were played.

By the mid-eighteenth century the population of Newcastle had risen to around 20,000. In the late eighteenth century, the city spread beyond the walls and suburbs were created.

In 1751, an infirmary was built in Newcastle. In 1777 a dispensary was opened where the poor could obtain free medicines. In 1755 Newcastle gained its first bank. After 1763 the streets inside the walls of Newcastle were lit by oil lamps and nightwatchmen patrolled them. A customs house was built in Newcastle in 1766. The Theatre Royal was first built in 1788. In 1773–81, a new bridge was built over the Tyne after the medieval one was destroyed by a storm.

In the eighteenth century, private companies began providing piped water but only a small number of people could afford it.

In the later eighteenth century, the salt industry in Newcastle declined but a pottery industry began to flourish. In the last part of the eighteenth century, work began on demolishing the walls and the gates at Newcastle since they impeded traffic.

In 1801, at the time of the first census Newcastle Upon Tyne had a population of 28,000. It grew rapidly. The population of Newcastle reached 53,000 in 1831. The boundaries were extended in 1835 to include Byker, Westgate, Elswick, Jesmond and Heaton.

In the years 1825–40, the centre of Newcastle was rebuilt. This was mostly the work of three men: John Dobson, an architect; Richard Grainger, a builder; and John Clayton, the town clerk. Dobson designed Eldon Square and Grainger built it 1825–31.

Thomas Oliver designed Leazes Terrace. Grainger built it in 1829–34. Dobson designed and Grainger built Grey Street in the 1830s. It was named after Earl Grey, prime minister in 1830–34. Earl Grey's monument was erected in 1838. Grainger also built the market named after him. A new Theatre Royal was built at that time. The Roman Catholic Cathedral of St Mary was built in 1844.

Like all nineteenth-century cities, Newcastle was dirty and unsanitary. An epidemic of cholera in 1832 killed 306 people. Another epidemic in 1848–49 killed 412. The worst outbreak was in 1853 when 1,533 people died.

However, there were some improvements in Newcastle during the nineteenth century. After 1818 the streets were lit by gas. In 1836, a modern police force was formed. In 1858 a Corn Exchange was built. So was a Town Hall.

In 1838 a railway was built from Newcastle to Carlisle. It was followed by one to Darlington in 1844 and one to Berwick in 1847. In 1849, a railway bridge, High Level Bridge, was built over the Tyne to connect Newcastle to London. Queen Victoria opened the central railway station, which was designed by Dobson in 1850.

In 1862 a memorial was erected to Stephenson. A swing bridge was erected in 1876 and Hancock Museum opened in the present building in 1884. The first public library in Newcastle opened in 1878. From 1879 horse-drawn trams ran in the streets of Newcastle.

The first public park in Newcastle, Leazes Park, was opened in 1873. In the 1870s the rest of Town Moor was laid out as parks, with Brandling Park opening in 1880.

A new diocese was created in 1882 and the Church of St Nicholas was made a cathedral. Newcastle became a city.

In the early nineteenth century, an alkali industry flourished in Newcastle but it had died out by the end of the century. The pottery industry and the glass industry also declined. During the nineteenth century shipbuilding continued to be important, as was the iron industry. Mechanical engineering also prospered in Newcastle.

Electric trams began to run in the streets of Newcastle upon Tyne in 1901 but they were in turn replaced by buses.

Laing Art Gallery was built in 1901, and Shipley Art Gallery opened in 1917. The first cinemas in Newcastle opened in 1909. The Redheugh road bridge crossing the Tyne to Gateshead was built in 1900. The King Edward VII railway bridge was built in 1906. Hatton Gallery was founded in 1925 and the suspension bridge, Tyne Bridge, was erected in 1928. In the 1920s and 1930s, the council built the first council houses in Newcastle. Many more were built after 1945.

Air raids on Newcastle during the Second World War caused 141 deaths and injured 587 more.

MAPS OF THE AREA COVERED

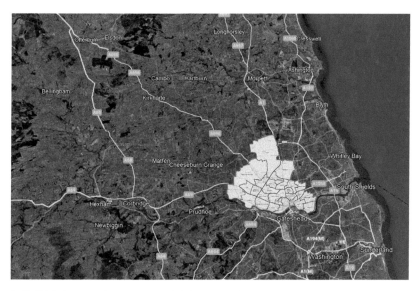

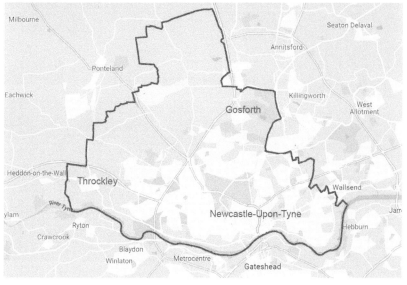

THE POSTCARD COLLECTION

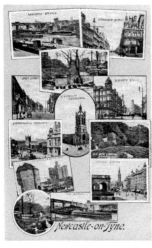

Multiview Postcards

These multiview postcards show many of the attractions in Newcastle and include images of the bridges, Central Station, St Thomas' Church, Jesmond Dene, St Nicholas' Cathedral, Largest Railway Crossing, Blackett Street, Grey Street, Grainger Street, Stephenson's Monument, All Saints Church, War Memorial, Black Gate and Castle, all of which are featured in this book.

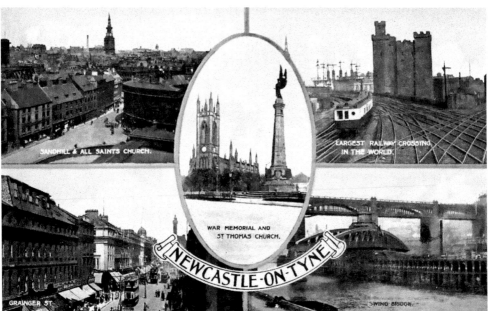

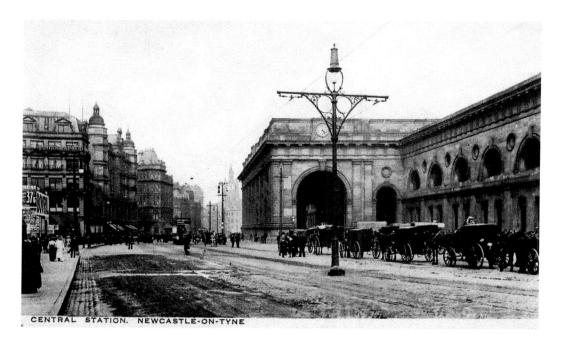

CENTRAL STATION. NEWCASTLE-ON-TYNE

Central Station

Newcastle Central station was opened in 1850 by Queen Victoria as part of the then Newcastle & Carlisle Railway and the York, Newcastle & Berwick Railway. The architect John Dobson produced general plans for the station, on a broad curve to front Neville Street so as to match the alignment of the railways from the east and west. There were three train shed roofs with spans of 60 feet. Extensive offices and refreshment facilities were included. Carriageway sidings were to the south. The original Dobson train shed was big enough to cope with traffic growth for thirty years. However, increasing usage meant that extensions had to take place. The images show the station façade with the portico.

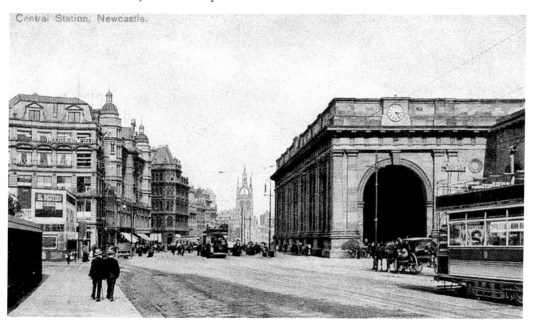

Central Station, Newcastle.

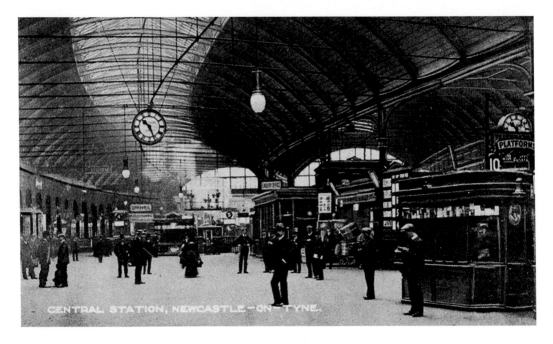

Central Station

The train shed extensions and buildings were designed by the company architect William Bell, and the work was completed in 1894. There were two distinct parts to the scheme. One was a southward extension of the train shed with two further spans. This allowed two of the existing through platforms to be replaced by a new island within the enlarged shed and the old platforms were stopped up in the middle, making them into bays and leaving space for an enlarged concourse. Top image is looking east and the bottom one looking west. Both show the concourse facilities.

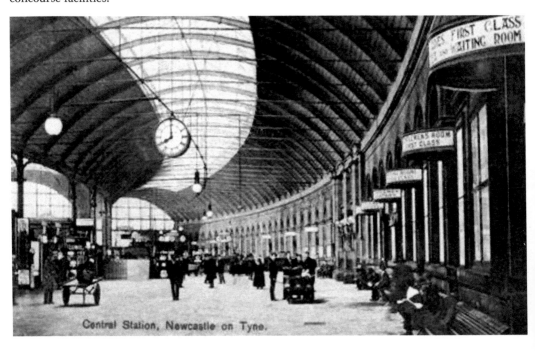

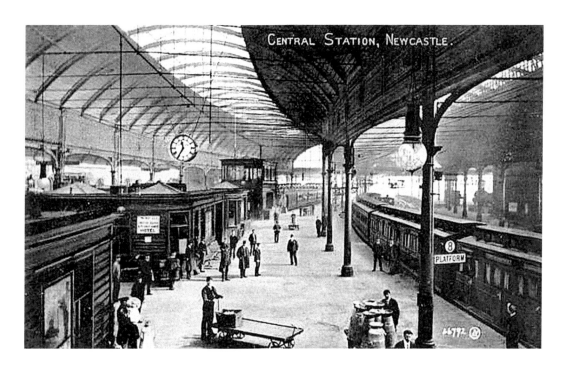

Central Station

The other element was an eastward extension of the station under a fully glazed ridge and furrow roof. This allowed the through platforms to be lengthened and a distinct suburban station to be formed, with its own concourse. The image above, looking east, shows on the left the stopped up rail and the new central concourse facilities. The image below is looking west and shows platforms 12, for trains to Blackhill via Scotswood, and 13, for the stopping train to Blaydon and Hexham.

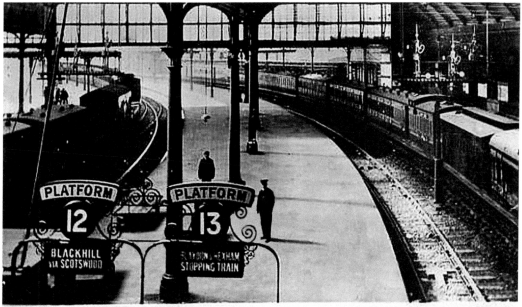

S 4092 WEST PLATFORMS, CENTRAL STATION, NEWCASTLE-ON-TYNE

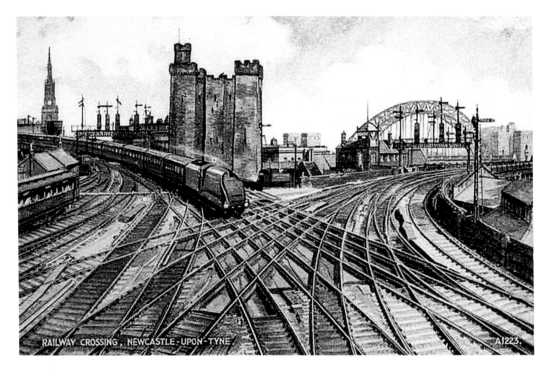

Railway Crossing, Central Station

Both the images are taken from the eastern end of the station looking in an easterly direction. The branch to the left of the castle keep in the centre is to Manors North and beyond. The branch to the right of the castle keep heads across the High Level Bridge over the River Tyne to Gateshead and beyond. The locomotive in the image above is in the blue livery of the A4 class. All Saints Church can be seen on the left and the Tyne Bridge is on the right.

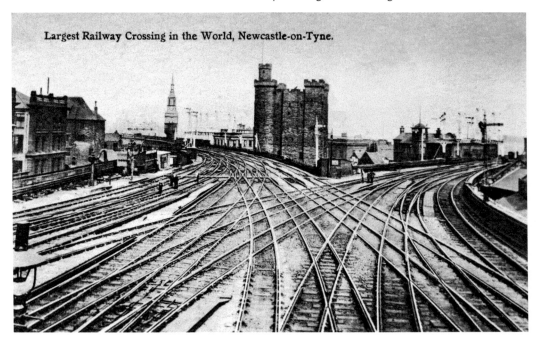

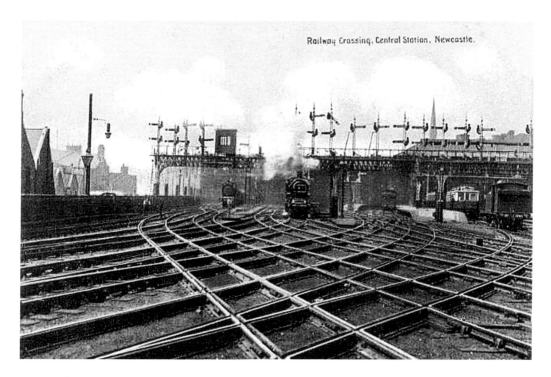

Railway Crossing, Central Station
The above image is looking west towards the eastern end of the station before the rail shed extension in 1894 and shows the signalling layout. The image below is also looking west but from a further distance and shows the full extent of the rail layout and shed extensions. Westgate Street, Neville Street, and St Mary's Cathedral are on the right of the images, and Forth Street is on the left. Note the NER Parcels Department notice on the image below.

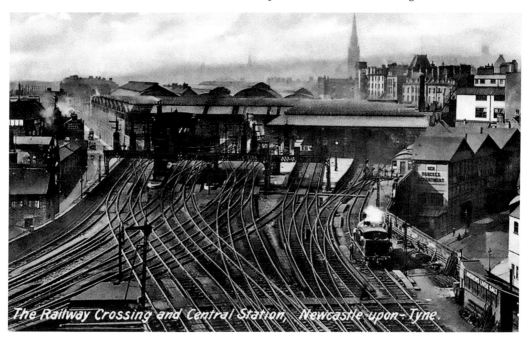

The Railway Crossing and Central Station, Newcastle-upon-Tyne.

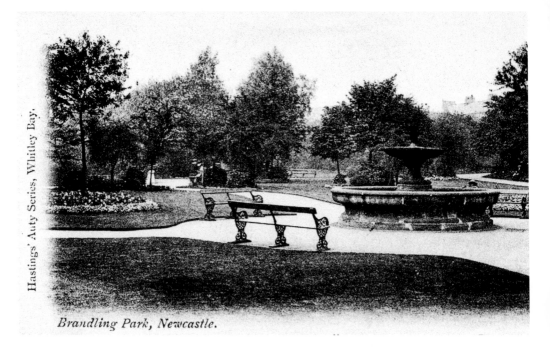

Brandling Park, Newcastle.

Brandling Park

The park was completed in 1878 and was officially opened in 1880. The Brandling family, after whom the park was named, played a leading role in Newcastle life for 450 years. They acted as mayors, businessmen, MPs, landowners, and mine owners. The images are taken looking north-east and show the ornamental fountain. The park is located near the junction of the Great North Road and Park Terrace and is close to the Exhibition Park.

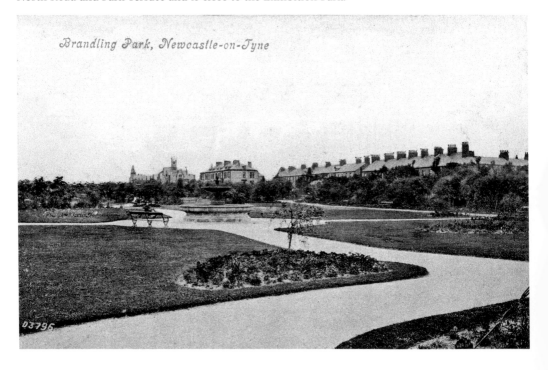

Brandling Park, Newcastle-on-Tyne

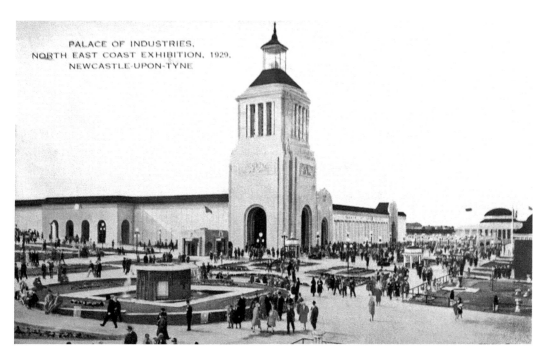

PALACE OF INDUSTRIES,
NORTH EAST COAST EXHIBITION, 1929,
NEWCASTLE-UPON-TYNE

North East Coast Exhibition

The North East Coast Exhibition was a world's fair that ran from May to October 1929. The event was held to encourage local heavy industry at the start of the Great Depression. It was opened by the Prince of Wales on the 14 May 1929. Over had 4 million people attended the exhibition by the time it closed on the 26 October 1929. It was held in the south-east corner of Town Moor at the junction of the Great North Road, Claremont Place, and Park Terrace.

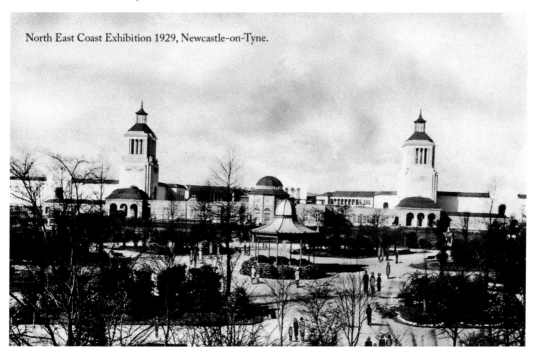

North East Coast Exhibition 1929, Newcastle-on-Tyne.

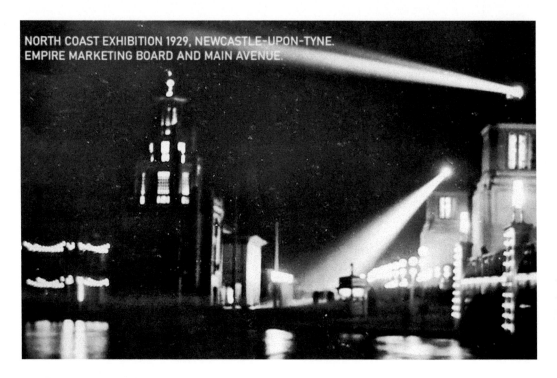

NORTH COAST EXHIBITION 1929, NEWCASTLE-UPON-TYNE.
EMPIRE MARKETING BOARD AND MAIN AVENUE.

North East Coast Exhibition

These images are taken on the bridge that ran from Main Avenue across the lake to the Palace of Arts. The images are looking towards the two towers of the Palaces of Industries and Engineering on the right and the Empire Market Board building on the left.

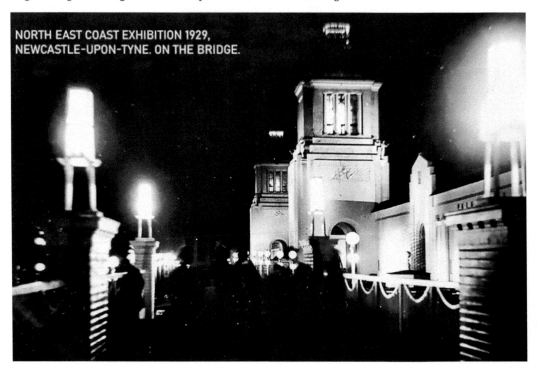

NORTH EAST COAST EXHIBITION 1929,
NEWCASTLE-UPON-TYNE. ON THE BRIDGE.

North East Coast Exhibition 1929, Newcastle-on-Tyne.
Bridge To Palace Of Arts.

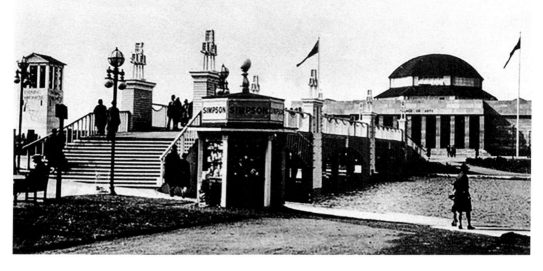

North East Coast Exhibition

The above image shows the bridge looking from Main Avenue across to the Palace of Arts Exhibitions Collection. Below is an artistic impression of the boating lake with the bridge in the background and visitors sitting in the paddle boats.

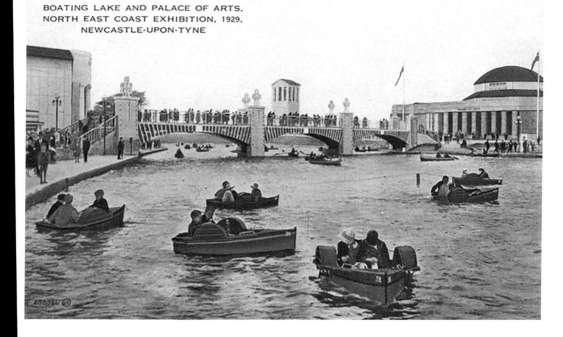

BOATING LAKE AND PALACE OF ARTS.
NORTH EAST COAST EXHIBITION, 1929,
NEWCASTLE-UPON-TYNE

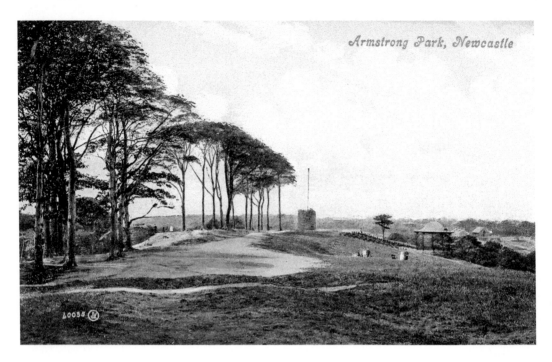

Armstrong Park

Armstrong Park was gifted to the people of Newcastle by Lord Armstrong in 1878 and is made up of mature woodland, steep valleys and grassland areas. The park connects with Jesmond Dene and Heaton Park to form a large green space that is a short distance north-east of the city centre. Bridges carry the paths over a sunken walkway of 1880. A stone well head called King John's Well lies alongside the westernmost path. The remains of an eighteenth-century windmill stands on a grassed area overlooking the wooded banks. The images show the remains of the windmill.

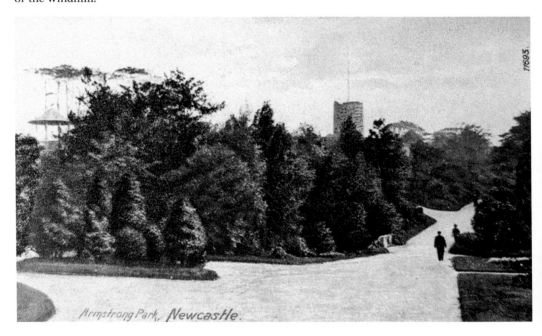

Armstrong Park, Newcastle.

NEW BRIDGE, ARMSTRONG PARK, NEWCASTLE-ON-TYNE.

Armstrong Park

These two images show the bridge connecting the Armstrong Bridge over Benton Bank to the park at its northern extremity. The path continues north to south the full length of the park to Jesmond Vale Lane.

IN ARMSTRONG PARK, NEWCASTLE-ON-TYNE.

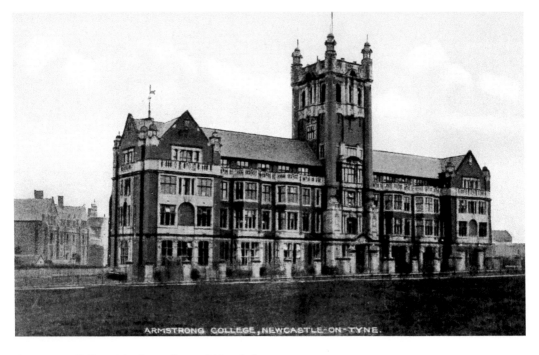

ARMSTRONG COLLEGE, NEWCASTLE-ON-TYNE.

Armstrong College Northern General Hospital

The college was founded in 1871 by the University of Durham, jointly with the North of England Institute of Mining and Mechanical Engineering as Durham College of Science and was later renamed as Armstrong College. The college was requisitioned by the War Office as a military hospital throughout the First World War and was called the First Northern General Hospital. In 1914 the provision was for 540 beds, but by 1917 this had risen to 2,166 and the unit also took over the Newcastle Workhouse Infirmary.

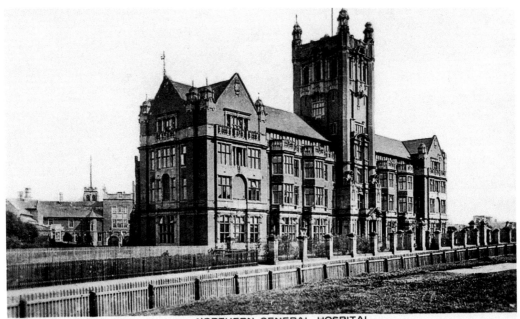

NORTHERN GENERAL HOSPITAL,

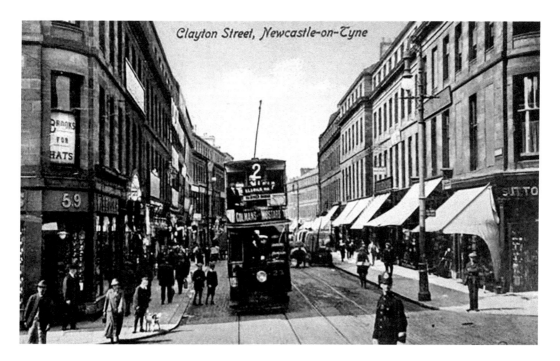

Clayton Street

The street runs from Westgate to Nelson Street and is approximately 0.29 miles long. It was built in 1837 by Richard Grainger and the street named after John Clayton, the nineteenth-century town clerk and antiquarian. At the time it joined up with Blackett Street. Both images are looking south-west towards Westgate Road. The top image is from the junction with Newgate Street and the one below from near to Falconers Court. The two domed structures are at the junction with Westgate Road.

CLAYTON STREET, NEWCASTLE ON TYNE Copyright.

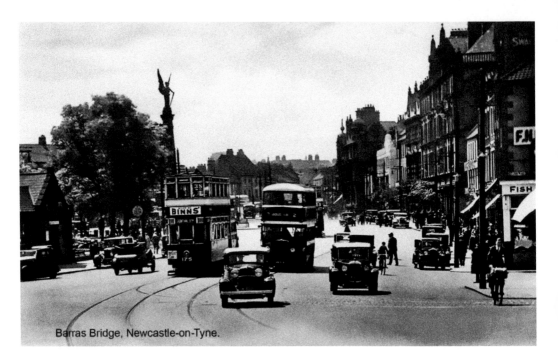

Barras Bridge, Newcastle-on-Tyne.

Barras Bridge

This road is a section of the Great North Road that leads towards the Haymarket and Percy Street. Barras Bridge was once a bridge that carried the Great North Road over the Pandon Dene, which was one of several streams that used to run through Newcastle and which were later covered. It is thought the name 'Barras' originated from the barrows, or burial mounds, of lepers at Mary Magdalene Hospital that once was located nearby. The South African War Memorial and the Church of St Thomas can be seen on the images.

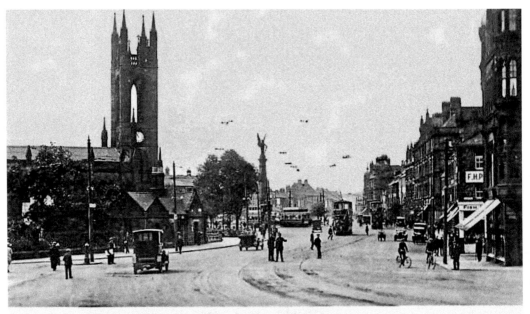

S.16452. BARRAS BRIDGE, NEWCASTLE-ON-TYNE.

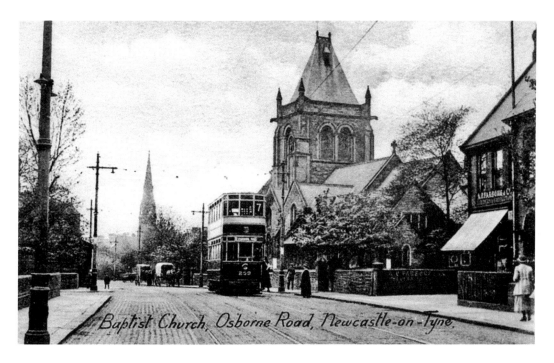

Baptist Church, Osborne Road, Newcastle-on-Tyne.

Osborne Road

This road is approximately 1.3 miles long and runs north to south between Jesmond Road in the south and Jesmond Dene Road, with two roughly east to west dog legs by North Jesmond Avenue and Lindisfarm Road. At the turn of the century, it was predominantly a residential area. The above image is looking south and just before Haldene Terrace to the right past the horse and carts All Saints Church can be seen in the background. The image below is looking north from the junction with Mistletoe Road and Queens Road with St George's Church in the background. Note the two-lane tram line sections on both images.

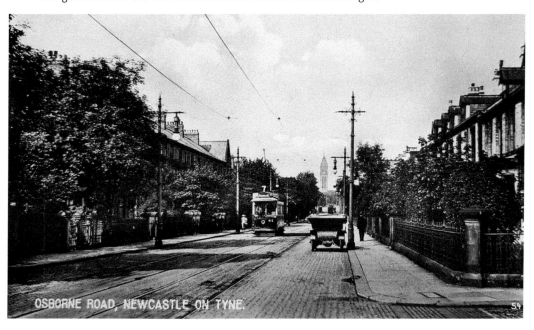

OSBORNE ROAD, NEWCASTLE ON TYNE.

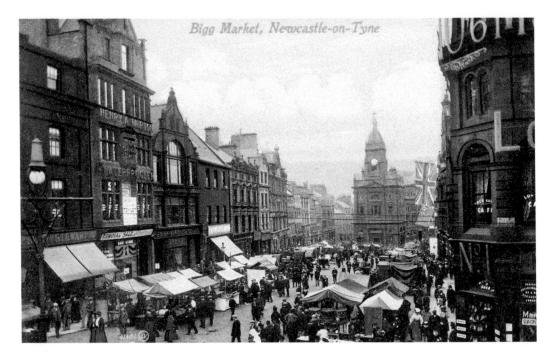

Bigg Market

The market is of historical significance and dates back to the Middle Ages when it was the site of a thriving marketplace that formed an important part of the Great North Road. The market was named after a type of coarse barley, called bigg, which was widely sold from the stalls. The images are looking in an easterly direction from near the junction with Grainger Street, and the old Town Hall is prominent with the clock tower. Cloth Market is to the left of the Town Hall and Groats Market to the right.

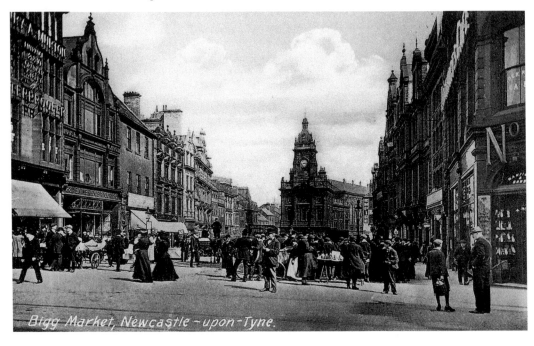

Castle

The 'New Castle', which gave the town its name, was founded in 1080 by the eldest son of William the Conqueror and built using earth and timber. Between 1168 and 1178, the castle was rebuilt in stone. Building work was interrupted in 1173 when the castle was besieged by the Scots, and again in 1174. This rebuilding produced the keep, as seen in the images.

By the early fourteenth century, the castle was enclosed by the completion of the Town Wall. In the 1600s parts of the castle were leased out and people began to build houses and shops in what was called the 'Castle Garth', which means the area within the old walls.

During the Civil War in 1642, the castle was briefly refortified and became the last stronghold of the town's Royalist defenders, who eventually surrendered in 1644 to the Parliamentarians.

After the Civil War houses were rebuilt and new ones were added until by the end of the eighteenth century the Castle Garth had become a densely populated community.

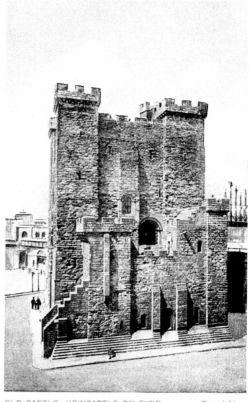

OLD CASTLE, NEWCASTLE ON TYNE. Copyright.

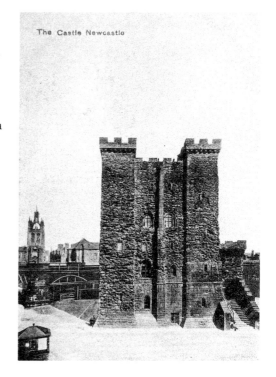

The Castle Newcastle

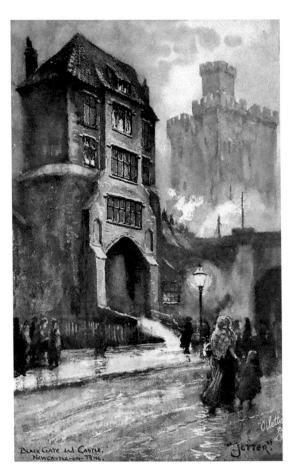

Black Gate and Castle,
Newcastle-on-Tyne.
"Jotter"

Black Gate
The images are looking in a
south-easterly direction along
St Nicholas Street from near to the
junction with The Side. Built between
1247 and 1250, during the reign of
King Henry III, The Black Gate was
the last addition to the medieval
Castle defences. The name 'Black
Gate' derives from Patrick Black,
a London merchant who occupied
the building in the first half of the
seventeenth century.

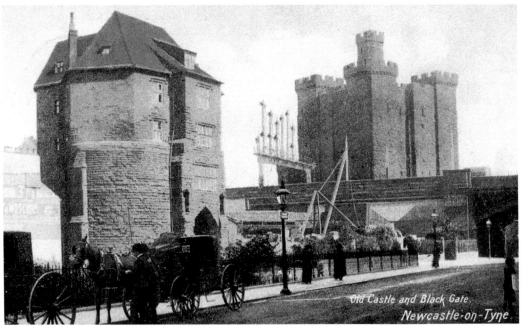

Old Castle and Black Gate.
Newcastle-on-Tyne

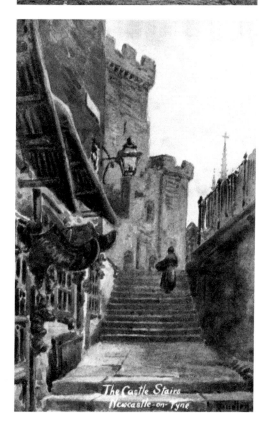

Castle Garth

The Castle Garth precincts became a resort and sanctuary for debtors and offenders against justice as it was controlled by the county of Northumberland, so the town authorities had no jurisdiction there. The tradesmen, who were not members of any of the Newcastle Guilds and who could not engage in business in the town, opened shops in defiance of the burghers and their laws.

Tailors and shoemakers seemed to have predominated in the locality. On either side of the steep stairs, there were open shop fronts with row upon row of boots, shoes, and clogs, new and second-hand.

The clearance of Castle Garth began in the early 1800s for the construction of the new Moot Hall, which was to replace the medieval moot hall as the County Court. From 1847 1849 further clearance made way for the railway viaduct.

The bottom image shows the castle steps leading to a postern in the gate tower to the keep. A postern is a secondary door or gate in a fortification such as a city wall or castle curtain wall.

The Castle Stairs
Newcastle-on-Tyne

27

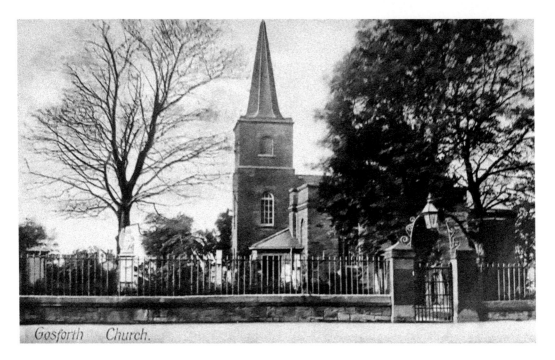

Gosforth Church.

Gosforth Parish Church

St Nicholas' parish church is located on Church Road in South Gosforth. In 1650 it was recommended that this chapel should be made the parish church of the district, but in 1663 it was said to have been destitute for two years and in ruins. It was described in 1715 as 11 by 8 yards, with a west tower 4 yards square, and built of stone and roofed with slate. A new chapel was built in 1799 by John Dodds after the demolition of the earlier one. In 1820 the church was extended and modified by John Dobson. There were further modifications in the early twentieth century.

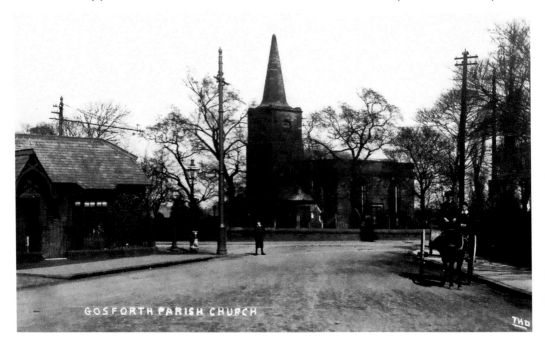

GOSFORTH PARISH CHURCH

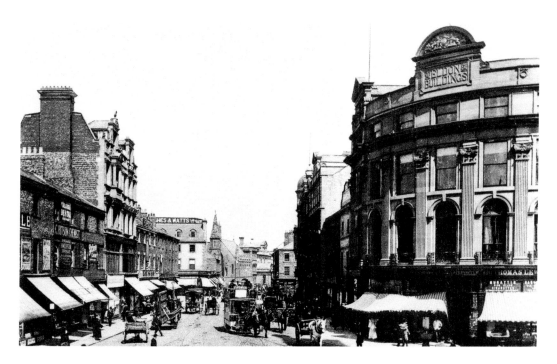

Blackett Street

This street follows the line of the early lane that ran outside the Town Wall between the New Gate and the Pilgrim Gate. It is approximately 0.22 miles long and runs east to west. The town wall was removed in the eighteenth century, and the street was improved in 1824 and named Blackett Street. It was named after John Erasmus Blackett, who was a mayor of Newcastle in the eighteenth century. The images are taken looking east from the junction of Greys Street, with the Eldon Buildings on the right-hand side.

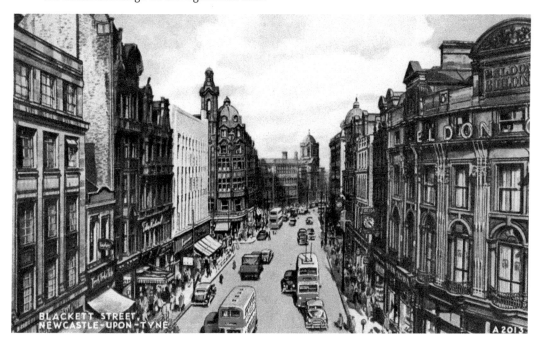

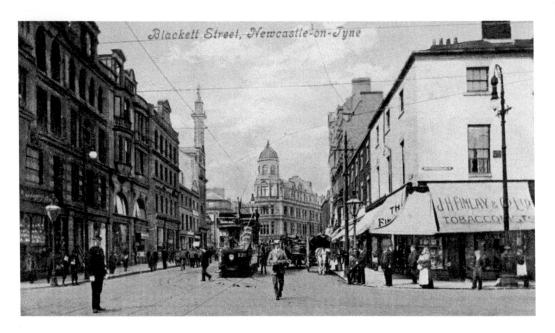

Blackett Street

The eastern section of Blackett Street, from the junction with Northumberland Street, includes the Northern Goldsmiths building, which was built in 1895, and the Eldon Buildings, built in 1897. The western section of the Blackett Street, after Grey's Monument, includes the Emmerson Chambers, which were built in 1903, and Eldon Square. The images are taken looking west from the junction with Northumberland Street. The Greys Monument and the YMCA building can be seen in the centre of the images.

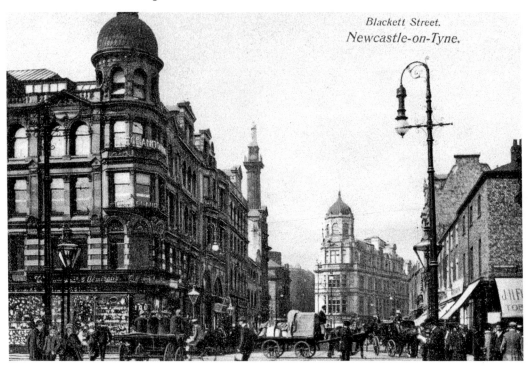

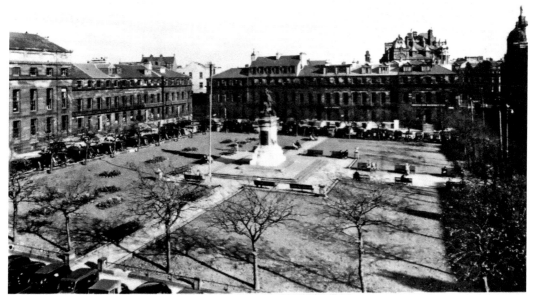

ELDON SQUARE, NEWCASTLE-ON-TYNE ᴀ TUCK ᴄᴀʀᴅ

Eldon Square

The square is on the northern side of Blackett Street and was bounded on three sides by Eldon Lane. Eldon Square was built as part of the 1825 to 1840 reconstruction of Newcastle city centre. In 1824 John Dobson was commissioned by Richard Grainger to produce designs for Eldon Square. The design was for three terraces facing a central square, each terrace being of two and a half storeys. The east and west terraces consisted of twenty-seven bays of windows, while the north terrace had thirty-nine bays. The images show the square with the three terraces.

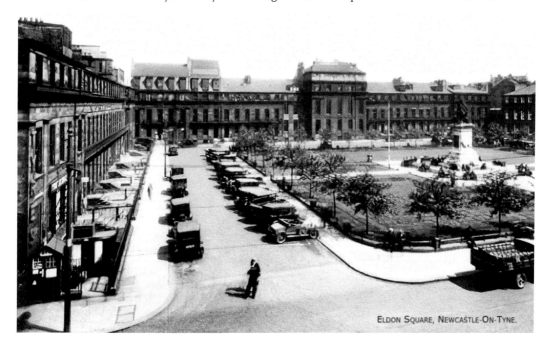

ELDON SQUARE, NEWCASTLE-ON-TYNE.

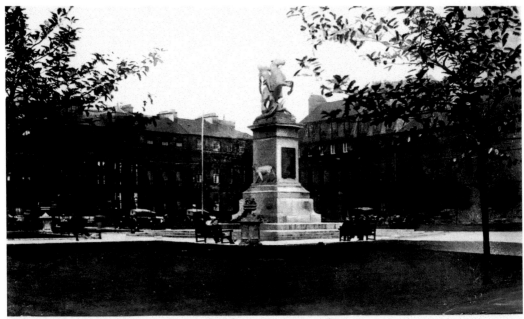

Eldon Square, Newcastle-on-Tyne.

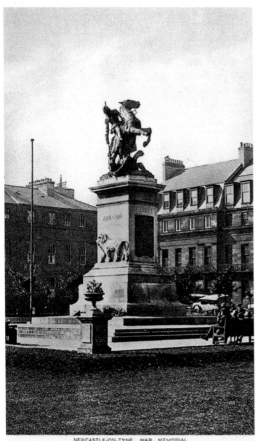

NEWCASTLE-ON-TYNE, WAR MEMORIAL

Eldon Square War Memorial

Designed by Charles Leonard Hartwell and unveiled by Earl Haig in 1923, the war memorial is situated at the centre of the square. It is a large Portland stone pedestal, with a different relief on each of the four sides, which are detailed below.

North: the words 'Memory Lingers Here' above a bronze sculptured wreath. South: a sculptured picture of a lion below the dates 1914–1918 and 1939–1945. East: a bronze relief of Justice, displaying two grieving women and a third holding the scales. West: a bronze relief of Peace, displaying a woman with a child and the Angel of Peace.

On the top is a large bronze equestrian statue of St George, the patron saint of infantrymen and cavalrymen, slaying a dragon. The pedestal was designed by Cackett and Burns.

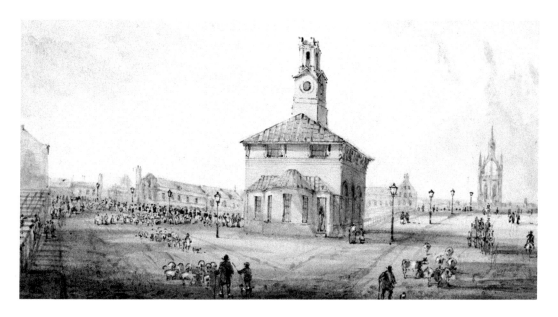

Cattle Market

Sheep and cattle markets were first held here on 27 July 1830. Cattle markets were held every Tuesday. In 1843 the space for holding the market was enlarged and proper facilities built. There were 618 pens for sheep, 9 fold yards for cattle with two entrances from the street, each 8 yards wide. By the 1900s, a new cattle market had been built with slaughter houses on the former Knox's Field. The former cattle market became a sheep and pig market. The images show the Market House situated near the junction of Scotswood Road and Marlborough Road. In the above image, St Mary's Cathedral can be seen. The Market Keeper's House and Office was designed by John Dobson in 1842.

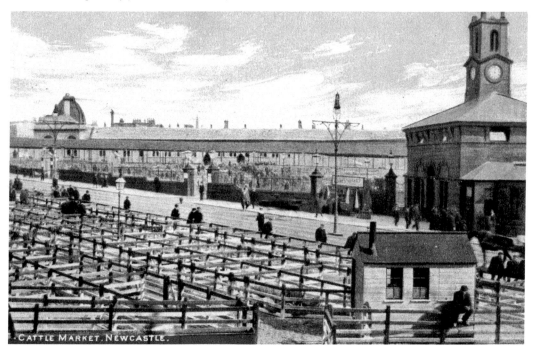

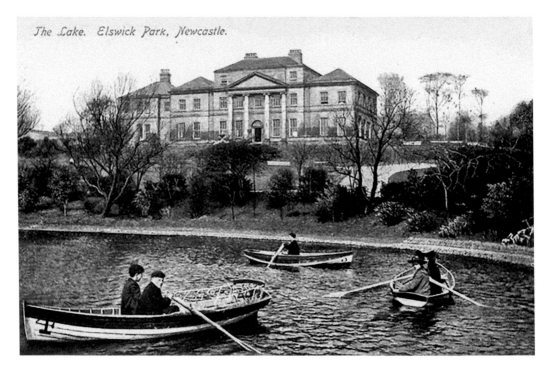

The Lake. Elswick Park, Newcastle.

Elswick Park

In the late nineteenth century, a group of Newcastle citizens purchased the Elswick Hall Estate and gave it to the city for use as a public park to prevent it being developed for housing. The park opened in 1881. The hall shown in these images was originally used for exhibiting a local sculptor's work. The hall was demolished in the 1980s. The ornamental lake in front of the hall was also used as a boating lake.

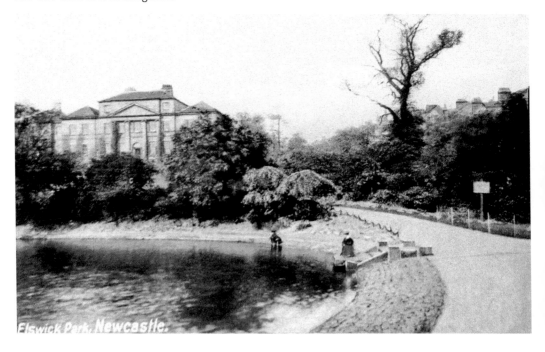

Elswick Park, Newcastle.

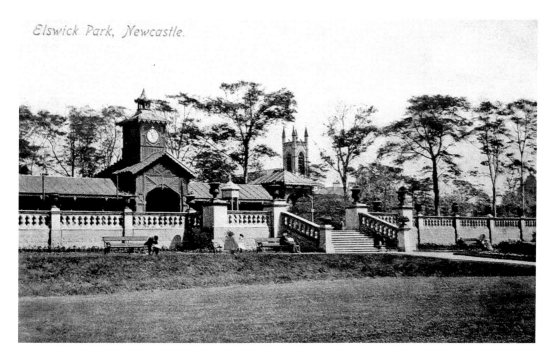

Elswick Park, Newcastle.

Elswick Park

The park also had a bowling green, rockery and a terrace in front of aviaries. A granite drinking fountain erected by subscription in 1881 is located at the top of the flight of steps shown in the above image. The drinking fountain was erected in recognition of the men who had been instrumental in procuring the park for the people of Newcastle. Both images show St Michael's Church in the background.

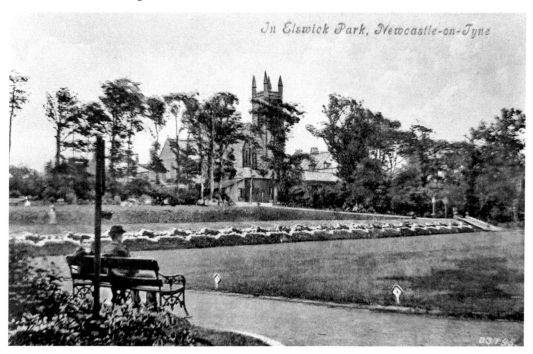

In Elswick Park, Newcastle-on-Tyne

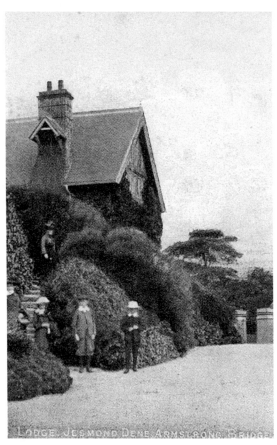

LODGE, JESMOND DENE, ARMSTRONG BRIDGE

Jesmond Dene

On the north side at the east end of Armstrong Bridge, there is an entrance into Jesmond Dene with stone gate piers and a lodge.

In the 1850s, William George Armstrong, later Lord Armstrong, the armament manufacturer, bought up large areas of the Ouse Burn valley. With his wife, he enclosed the land and transformed it into landscaped parkland.

With his fascination for water, it is no surprise that he altered the river. A large waterfall, weirs and rock islands were created near to the mill, along with several bridges including the one from which to view the waterfall, and a network of footpaths.

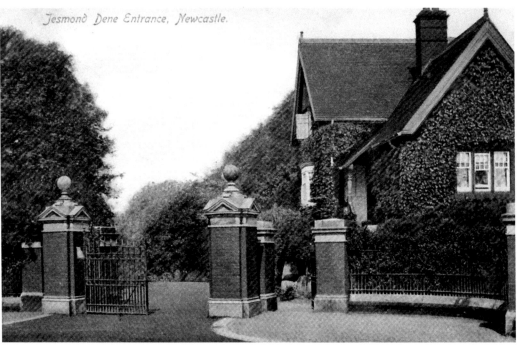

Jesmond Dene Entrance, Newcastle.

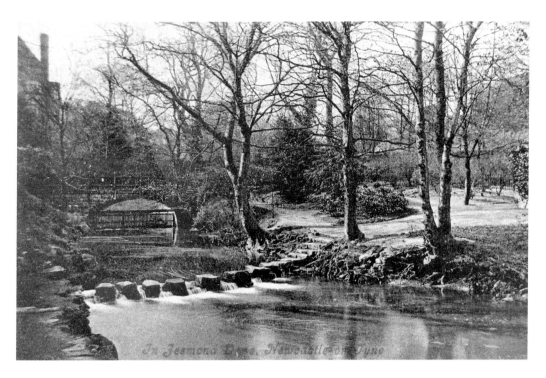

Jesmond Dene

These images show the bridge and the stepping stones below the North Lodge, which is shown on the right of the image below but is just out of shot in the above image. Jesmond Dene Lodge is showing on the left of the above image.

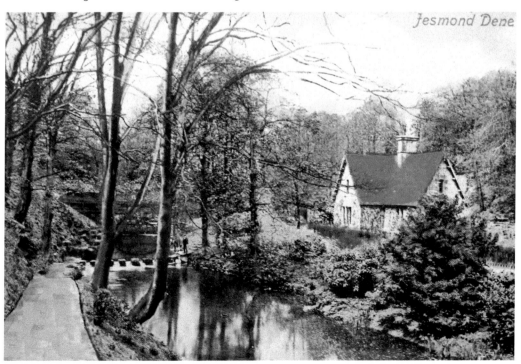

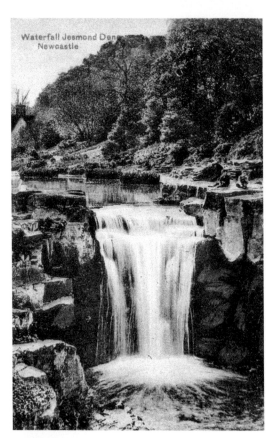

Jesmond Dene
The waterfall is the biggest alteration to the river and was a result of blasting out the riverbed downstream, while building up the area upstream. He also had a bridge installed to enable viewing of the waterfall. They additionally introduced exotic non-native species of trees and shrubs such as cedars, junipers, Californian redwoods and the rhododendron.

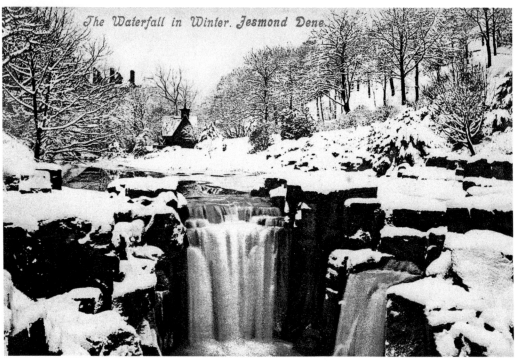

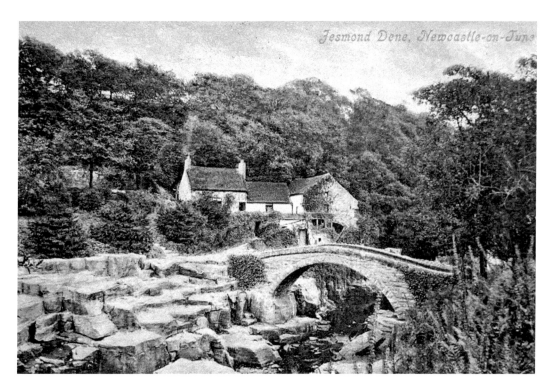

Jesmond Dene

Below the waterfall stands the old watermill, which is one of many mills that bordered the Ouse Burn in past years. Dating back to the thirteenth century, the mill was occupied for three or four generations by the Freeman family who used it as a flour mill.

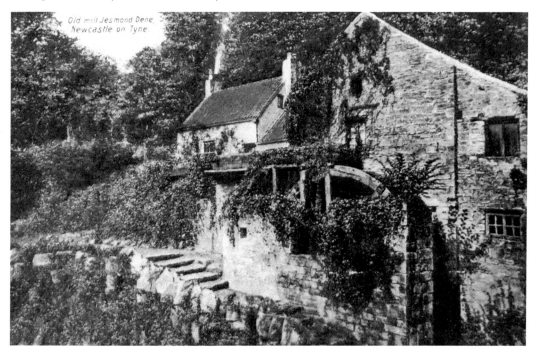

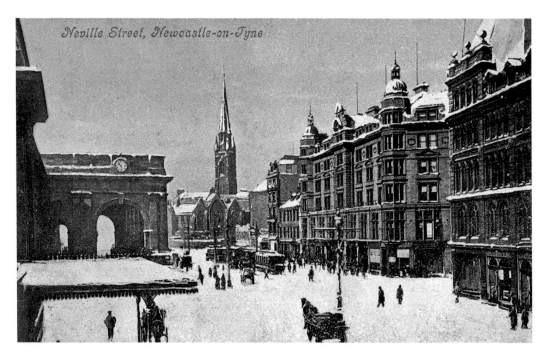

Neville Street, Newcastle-on-Tyne

Neville Street

This street was built in 1835 to connect Collingwood Street with Scotswood Road and was part of the nineteenth-century redevelopment of the city centre. In building the street a large section of the medieval Town Walls, including Stank Tower, were demolished. The street is approximately 0.26 miles long and runs in an east to west direction. The two images are taken looking west from outside Central station. The portico to the station is on the left and St Mary's Cathedral is central.

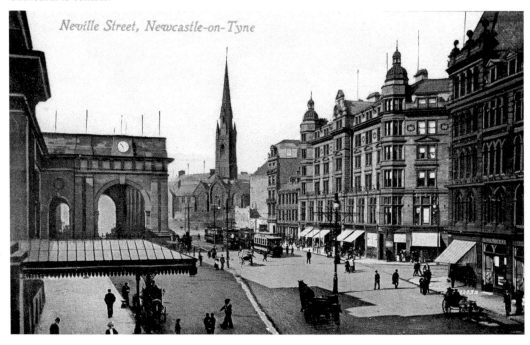

Neville Street, Newcastle-on-Tyne

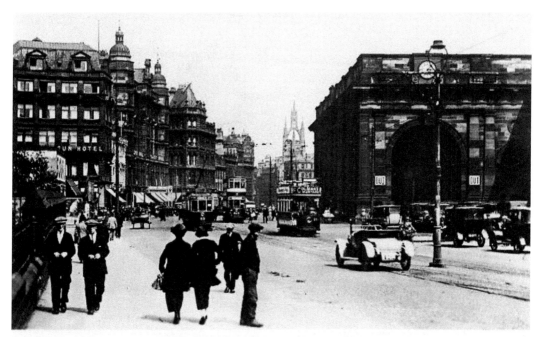

S.16448. NEVILLE STREET & CENTRAL STATION, NEWCASTLE-ON-TYNE.

Neville Street

The street was named after the Neville family, who were Earls of Westmorland, though their power base was actually in County Durham and at Middleham Castle in Yorkshire. Neville Street has many notable buildings, including Central station and the Royal Station Hotel. The images are taken looking east with the Central station portico on the right and just past that is the Royal Station Hotel. St Nicholas' Cathedral is seen in the centre background.

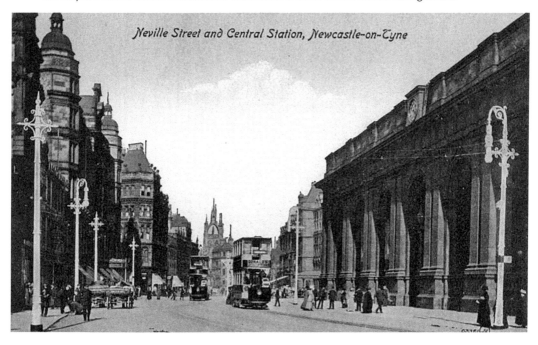

Neville Street and Central Station, Newcastle-on-Tyne

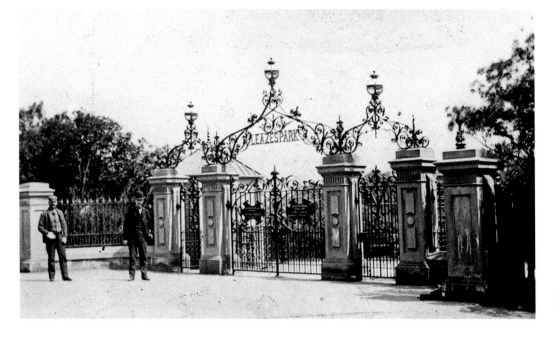

Leazes Park

On 23 December 1873, Leazes Park was officially opened by Alderman Sir Charles Hamond. It was the first purpose-built park in Newcastle. The park is located on the northern limits of the city centre and provides a contrast with the wide open space of the Town Moor, which is close by. The above image shows the grand Jubilee Gates at the Richardson Road entrance, which were added in 1896 to commemorate the Diamond Jubilee of Queen Victoria. The layout of the park centres on the lake, which is shown in the image below.

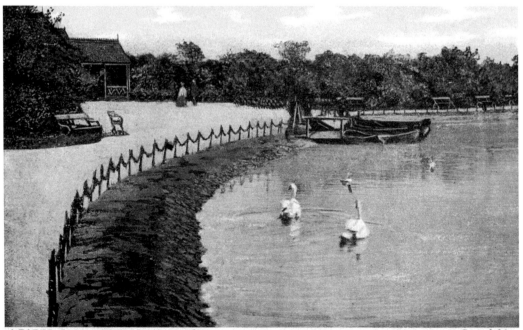

LEAZES PARK, NEWCASTLE ON TYNE Copyright.

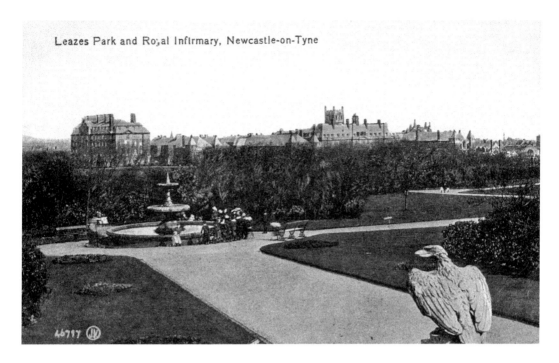

Leazes Park

A bandstand was added in 1875, and a balustraded stone terrace in 1879. A second lake was created in 1893 but this was filled in by 1949 and the area used for a bowling green and tennis court. The image above shows the ornate fountain in front of the stone balustraded terrace and is taken looking north-east. The image below shows the bandstand, which is off to the right of the above image. Both images show the Armstrong College tower in the background.

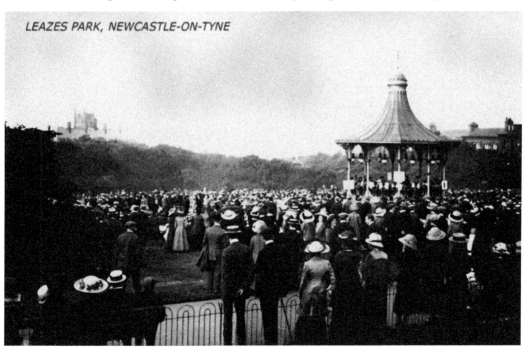

LEAZES PARK, NEWCASTLE-ON-TYNE

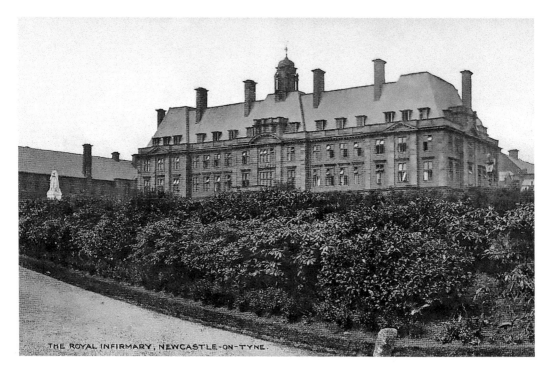

THE ROYAL INFIRMARY, NEWCASTLE-ON-TYNE.

Royal Victoria Hospital

King Edward VII opened the new Royal Victoria Infirmary in Newcastle on 11 July 1906. It replaced the old Infirmary on Forth Banks, which had been founded in 1751. The new hospital was built on 10 acres of Town Moor that was given by the Corporation and Freemen of Newcastle. The image below is taken from the edge of the lake in Leazes Park.

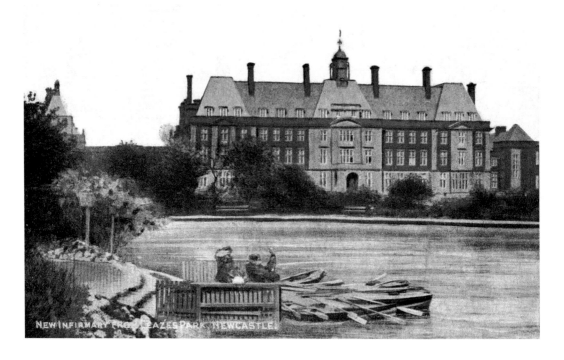

NEW INFIRMARY FROM LEAZES PARK, NEWCASTLE.

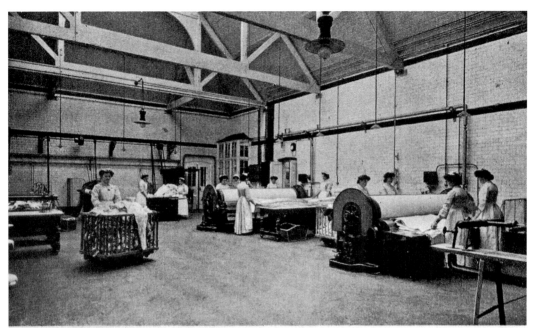

THE LAUNDRY,
Royal Victoria Infirmary, Newcastle-upon-Tyne

Thompson and Lee, Photo, N/C.

Royal Victoria Hospital

The fully furnished and equipped hospital contained seventeen wards, a nurses' home, chapel, five operating theatres and ancillary facilities such as the kitchen and the laundry room, which is shown in the above image. The image below shows the well laid out and naturally illuminated Ward 6.

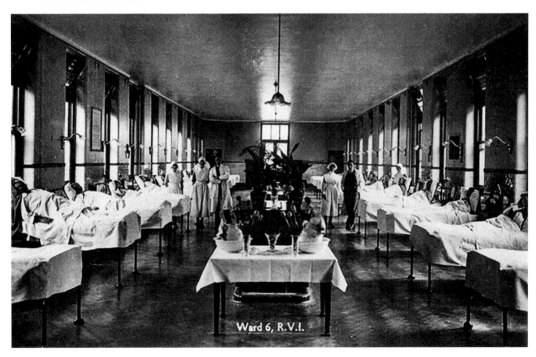

Ward 6, R.V.I.

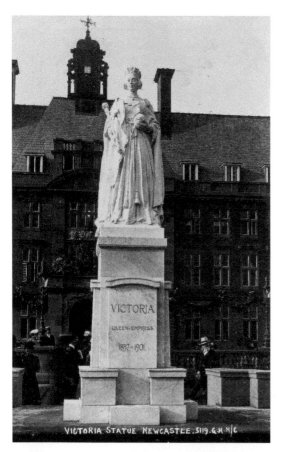

VICTORIA STATUE NEWCASTLE. 5119. G.H. H/C

Royal Victoria Hospital Victoria Statue

The statue of a young Queen Victoria on the front lawn of the Royal Victoria Infirmary was unveiled by King Edward VII at the same time as he opened the hospital. The white marble statue, by G. Frampton R. A., was a gift from Sir Riley Lord, who was later knighted for his part in getting the Infirmary built.

The over-life-size white marble statue stands upon a high square pedestal, also of white marble, with four low square buttresses at the corners. The statue and pedestal, 22 feet in height, stand on a paved square sandstone terrace with indented corners and steps surrounded by dwarf walls.

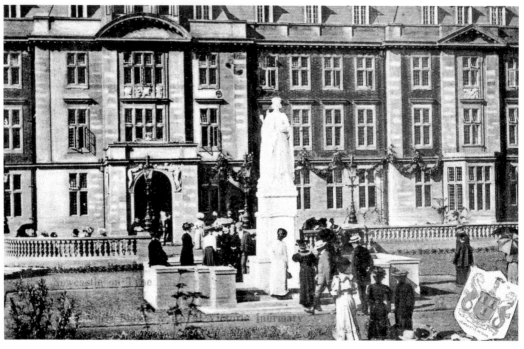

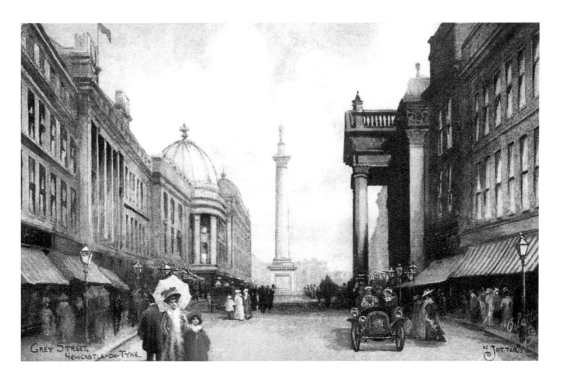

Grey Street

The street runs between Mosely Street and Blackett Street and is approximately 0.33 miles long. The street was initially called Upper Dean Street but was subsequently renamed as Grey Street in honour of Charles, 2nd Earl Grey. The images are looking northwards from near to High Bridge with the Theatre Royal portico on the right, Greys Monument at the end of the street and the domes of the Central Arcade are seen on the left.

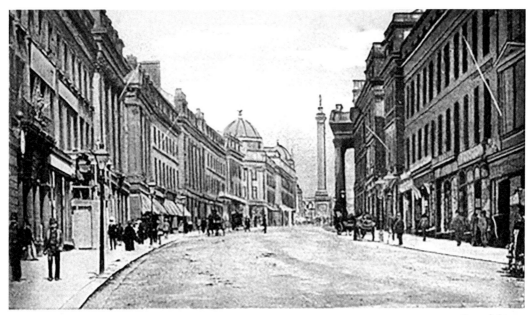

NEWCASTLE ON TYNE. GREY STREET Copyright.

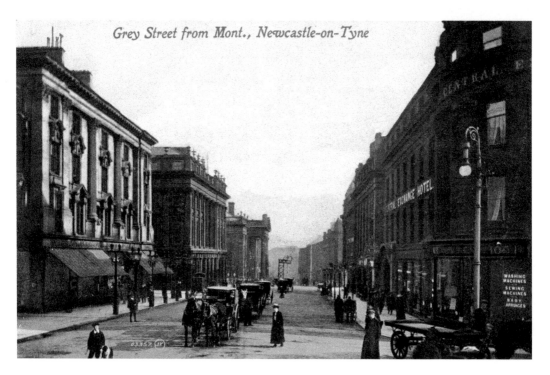

Grey Street from Mont., Newcastle-on-Tyne

Grey Street

Both Grey Street and Dean Street follow the course of Lort Burn, which flows from Leazes Park to the Tyne. It was used as an open sewer in medieval times, but it was culverted in around 1784. Grey Street was built by Richard Grainger, and it was completed in 1837. The images are taken looking away from the monument and show the Theatre Royal on the left and the Exchange Hotel on the right.

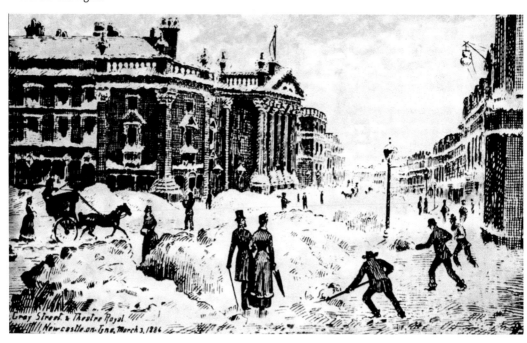

The Theatre Royal

The original Theatre Royal opened on 21 January 1788. The original theatre's location on Mosley Street obstructed plans for the redevelopment of the city centre, as it was on the route of Grey Street, so it was demolished. The new theatre opened on 20 February 1837 with a performance of *The Merchant of Venice*. The new Theatre Royal was a 'flagship' of Richard Grainger's redevelopment of Newcastle city centre in a neoclassical style. The theatre was designed by local architects John and Benjamin Green and features one of the country's finest theatre façades. In 1901, after the original interior had been destroyed by fire in 1899, a grand auditorium was added, which was designed by Frank Matcham.

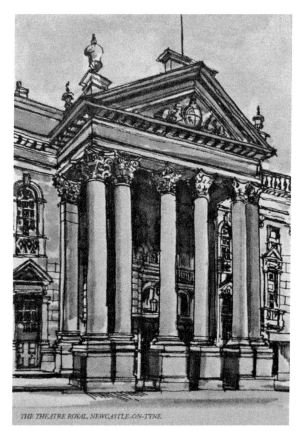

THE THEATRE ROYAL, NEWCASTLE-ON-TYNE.

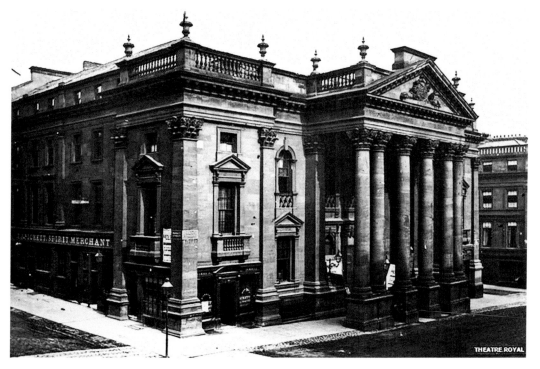

THEATRE ROYAL

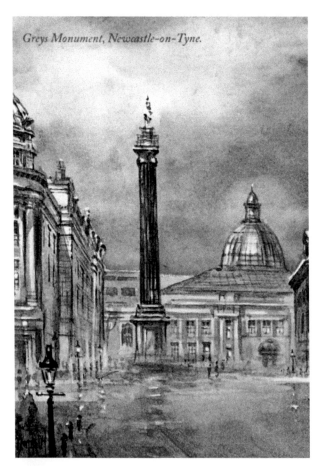

Greys Monument, Newcastle-on-Tyne.

Greys Monument

The foundation stone was laid on 6 September 1837 and the monument was completed in August 1838. Grey's Monument was built to commemorate Earl Grey, a local politician who was British prime minister from 1830 to 1834. The monument was also erected to celebrate the passing of the Reform Act 1832, which attempted to stamp out corruption and increase the number of people eligible to vote. The column stands at 134 feet; it was intended to be 150 feet but not enough money was raised. A time capsule was buried underneath the foundation stone. It contained a drawing of the monument, a list of subscribers to its erection and a collection of coins, medals and tokens.

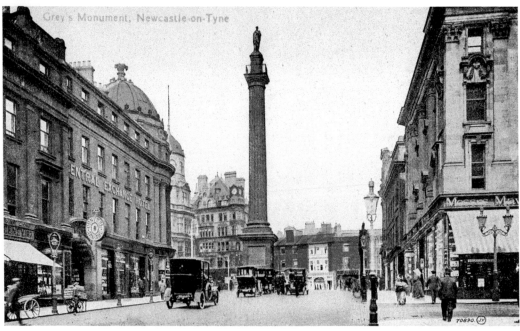

Grey's Monument, Newcastle-on-Tyne

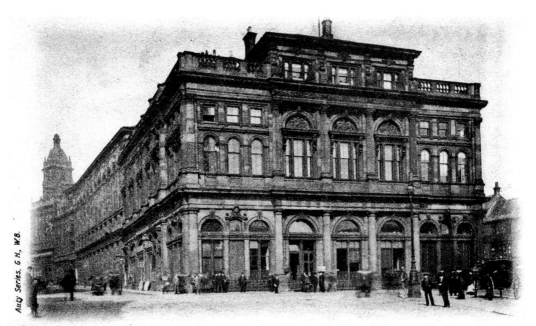

Town Hall, Newcastle

1275

Town Hall

The foundation stone for the new town hall was laid by the mayor, Sir Isaac Lowthian Bell, in 1855. The design, which was undertaken by John Johnstone in the Italian neoclassical style, involved incorporating the Corn Exchange into the central section of the building as an assembly hall. The design also involved a council chamber and municipal offices for Newcastle Town Council. The main frontage of the new building faced the cathedral. The works were completed in 1863.

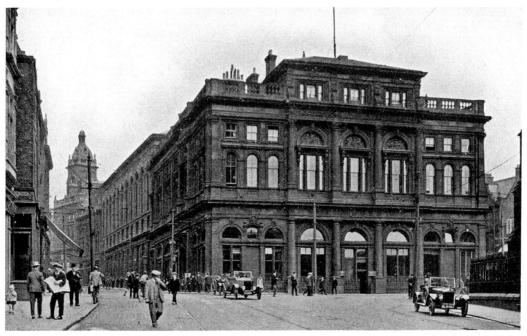

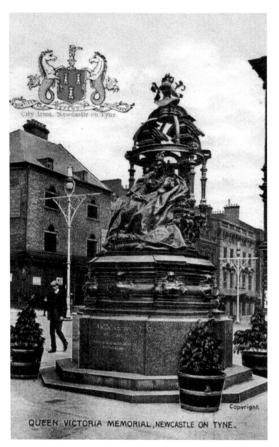

QUEEN VICTORIA MEMORIAL, NEWCASTLE ON TYNE.

Queen Victoria Monument

The bronze statue of Queen Victoria in St Nicholas' Square, as shown on the top image, was unveiled on 24 April 1903. The monument was designed by Alfred Gilbert and is based on one that is in Winchester Castle. The monument has a pink granite pedestal, with diagonal pilasters and bowed sides. The seated figure in chair has an elaborate canopy and base. The pedestal is inscribed with 'The Throne Is Established By Righteousness'. The monument was the gift of W. H. Stephenson to commemorate 500 years of there being a Sheriff of Newcastle, 1400–1900.

The image below shows the monument on the square with St Nicholas Church to the right and the Town Hall to the left.

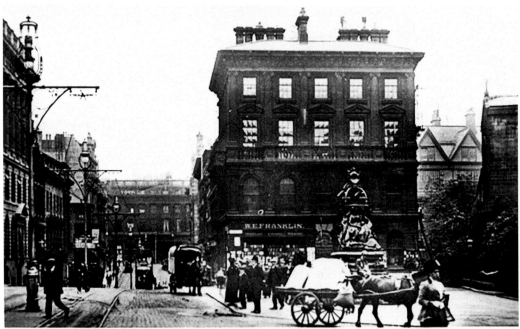

MOSLEY STREET, NEWCASTLE-ON-TYNE.

Cowan Monument

The monument is located at the junction of Westgate Road and Fenkle Street. The statue, by John Tweed, was erected in 1906 by public subscription. It was unveiled by Lord Ridley on 7 July 1906. The bronze statue standing upon a curved pedestal is inscribed 'Joseph Cowen 1829 – 1900. Erected by Public Subscription 1906.'

Joseph Cowen, the elder, made his money manufacturing bricks and clay products in the Blaydon Burn, Gateshead, was a leading advocate of parliamentary reform and of the repeal of the Corn Laws and became Member of Parliament for Newcastle in the 1860s. His son, the subject of the statue, carried on the liberal family tradition and also became a Member of Parliament for the city. In 1862, he bought the *Newcastle Chronicle*.

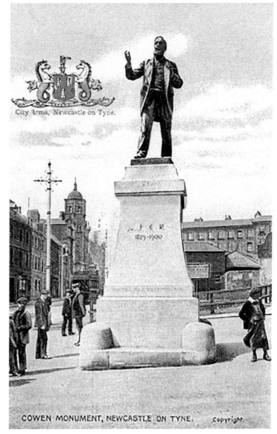

COWEN MONUMENT, NEWCASTLE ON TYNE. Copyright.

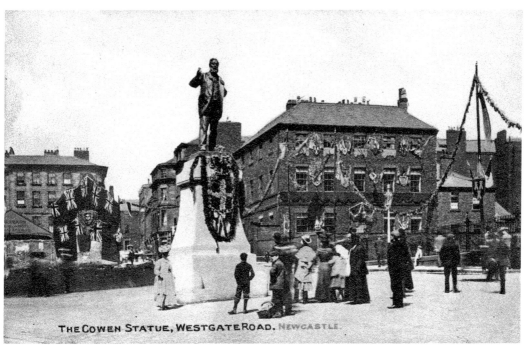

THE COWEN STATUE, WESTGATE ROAD, NEWCASTLE

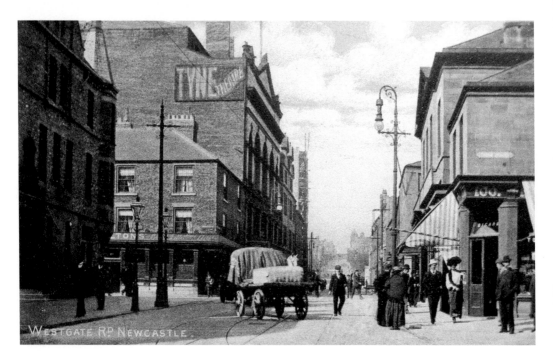

Westgate Road

The road takes its name from the West Gate of the Town Walls. The road runs in a westerly direction from St Nicholas Street to West Road where the site of the toll house was and is approximately 2.85 miles long. The above image is taken from the junction of Thornton Street on the left and Bath Lane on right. The Tyne Theatre is shown. The image below is from Blandford Street, now Blandford Square. Note the domed tower of the hall at the junction of Corporation Street in the far distance on both images. Both images are looking in a westerly direction.

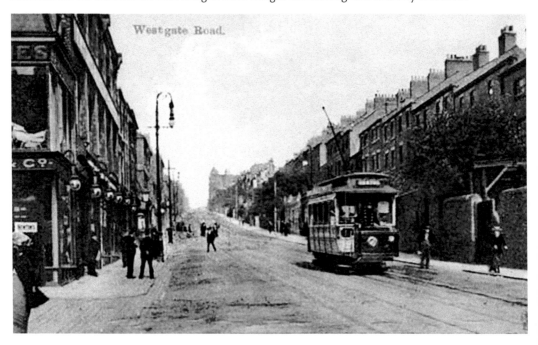

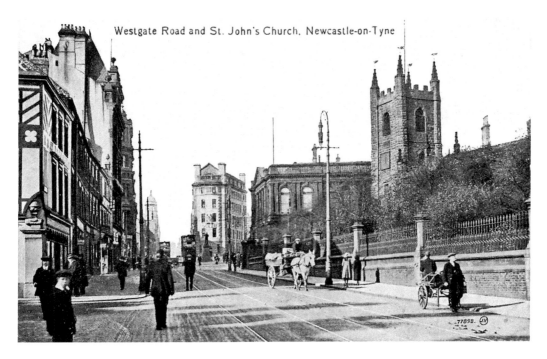

Westgate Road and St. John's Church, Newcastle-on-Tyne

St John's Church

This is a thirteenth-century church on the corner of Grainger Street and Westgate Road and is dedicated to St John the Baptist. The church, founded prior to 1286, is a spacious cruciform structure in the early English style, with a square embattled tower and angular turret. The church contains several old monuments and an ancient font. In the churchyard are the remains of John Cunningham, the pastoral poet, who died in 1773. The two images show views from Westgate Road and Grainger Street West.

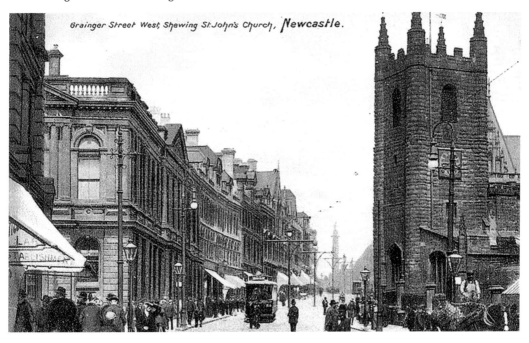

Grainger Street West, Shewing St John's Church, Newcastle.

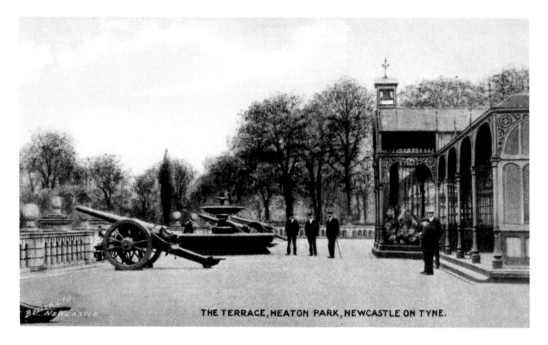

THE TERRACE, HEATON PARK, NEWCASTLE ON TYNE.

Heaton Park

Heaton Park first opened in 1879 when the corporation acquired 22.5 acres of the Heaton Hall estate from Addison Potter. The two main entrances to Heaton Park are from Heaton Park View and from Jesmond Vale Road. The main features of the park included a Victorian Terrace as shown on the two images, an eighteenth-century garden temple removed in the early twentieth century and the remains of a twelfth-century tower house called King John's Palace, which was also known as Adam of Jesmond's Camera.

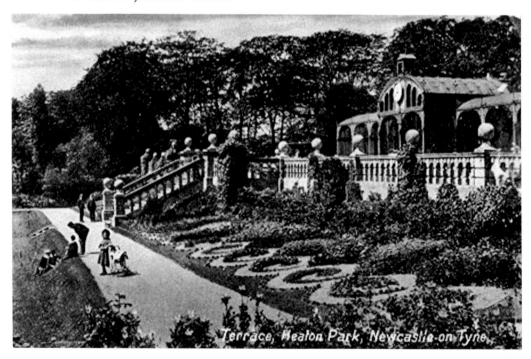

Terrace, Heaton Park, Newcastle-on-Tyne.

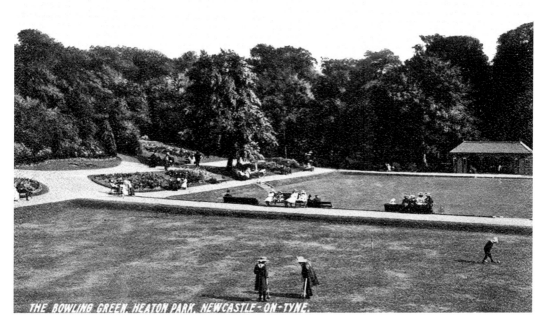

THE BOWLING GREEN, HEATON PARK, NEWCASTLE-ON-TYNE.

Heaton Park

The Victorian pavilion and terrace, dating back to 1880, is in the north of the park, and this overlooked a croquet ground and bowling green. The image above, taken from the terrace, shows people playing croquet in the foreground with the bowling green and club house beyond that. The image below shows the pavilion and greens looking north-west.

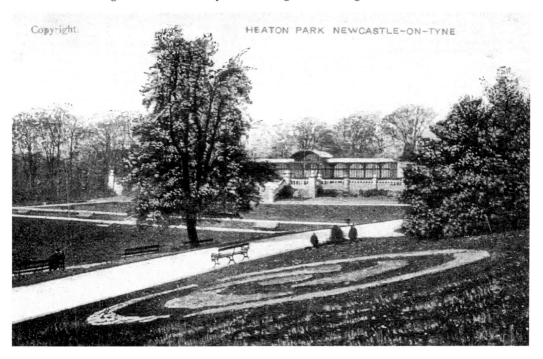

Copyright. HEATON PARK NEWCASTLE-ON-TYNE

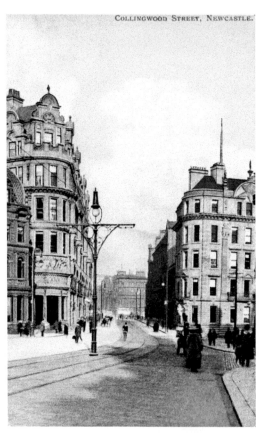

Collingwood Street

This street was built by Newcastle Corporation in 1809 to link the Cloth Market to Westgate Road. The road is approximately 0.1 miles long. The street was named after Newcastle-born Admiral Lord Cuthbert Collingwood (1748–1810), who was second in command at the Battle of Trafalgar.

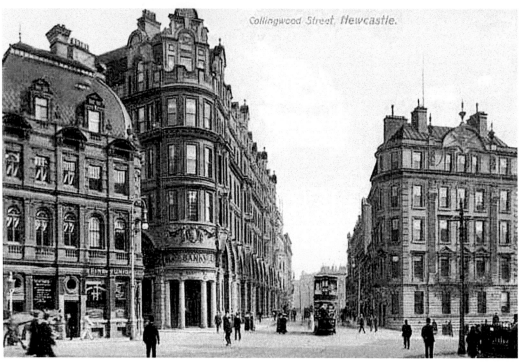

Collingwood Street, Newcastle.

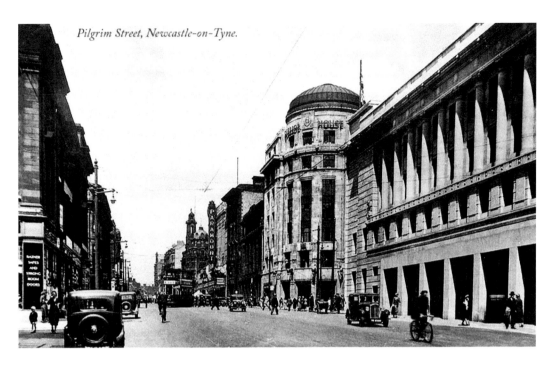

Pilgrim Street, Newcastle-on-Tyne.

Pilgrim Street

The name is said to derive from pilgrims visiting the chapel of St Mary in Jesmond, where miracles supposedly occurred in medieval times. At the time of the images, the street was approximately 0.27 miles long and ran from near to the Side to New Bridge Road. The image above is looking north from near to the junction of Worswick Street with Hood Street on the left. The image below is looking in the same direction from further along the street near to junction with New Bridge Street. The Paramount cinema can be seen on both images.

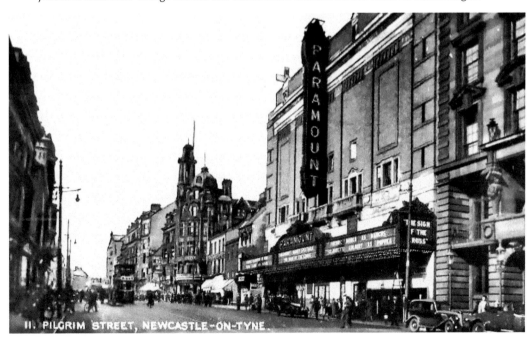

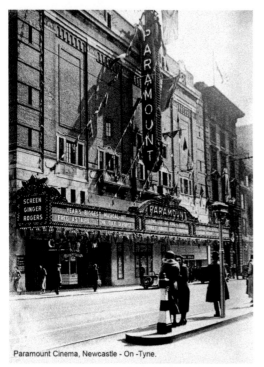

Paramount Cinema, Newcastle - On -Tyne.

Paramount Cinema

Situated on Pilgrim Street, the cinema opened on Monday 7 September 1931 with Jack Buchanan and Jeanette MacDonald in *Monte Carlo*, and a stage presentation by Francis A. Mangan *The Ladder of Roses*. The theatre was designed as a dual-purpose cinema and variety show facility. The building was designed by the architects Verity and Beverly with an interior designed in the Baroque style.

The interior was very opulent with silk panels and more than 500 motives and paintings applied directly to the walls.

There was a full 30-foot-deep stage behind the 54-foot area in front of the curtain and a Wurlitzer organ rose up to the left of the stage. In the basement was a restaurant.

On 27 November 1939, all the Paramount theatres were sold to Odeon and the Newcastle Paramount was renamed Odeon on 22 April 1940.

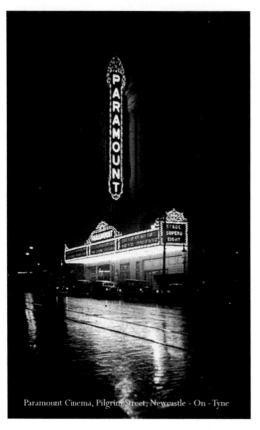

Paramount Cinema, Pilgrim Street, Newcastle - On - Tyne

All Saints Church

It is located at the southern end of Pilgrim Street and is a parish church built between 1786 and 1796 by David Stephenson. It replaced an earlier medieval church. The foundation stone was laid on 14 August 1786 by Revd James Stephen Lushington, vicar of Newcastle.

The church is built in the form of an ellipse, the longer diameter of which runs nearly north and south. The square tower on which the steeple stands is at the south end, and the interior forms the vestibule. On either side of it there is a wing, that on the left being used as a morning chapel and for baptisms, and that on the right as the vestry. The height of the church to the top of the spire is 202 feet.

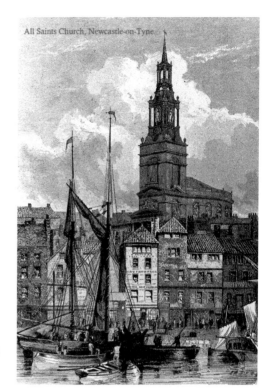

All Saints Church, Newcastle-on-Tyne

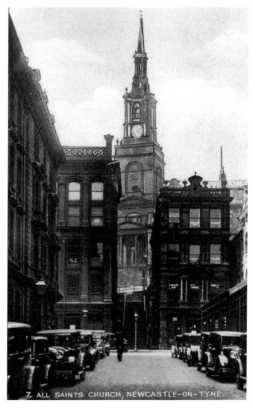

Z ALL SAINTS CHURCH, NEWCASTLE-ON-TYNE.

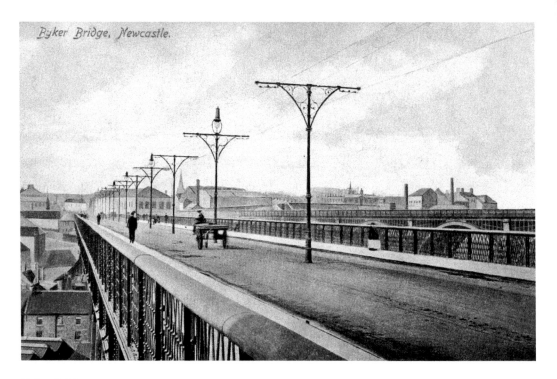

Byker Bridge, Newcastle.

Byker Bridge

The bridge is a 1,130-foot-long road bridge and carries traffic over the Ouseburn Valley. The bridge was opened to pedestrians on 19 October 1878, and then to carts and carriages on 27 January 1879. There was originally a half penny toll, which was withdrawn on 12 April 1895. Robert Hodgson, brother-in-law of Thomas Elliot Harrison, engineer in chief for the North Eastern Railway, was the engineer on the Byker Bridge.

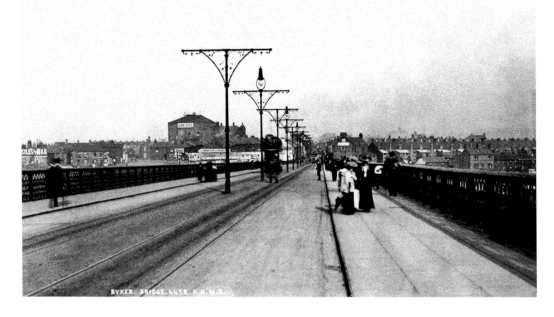

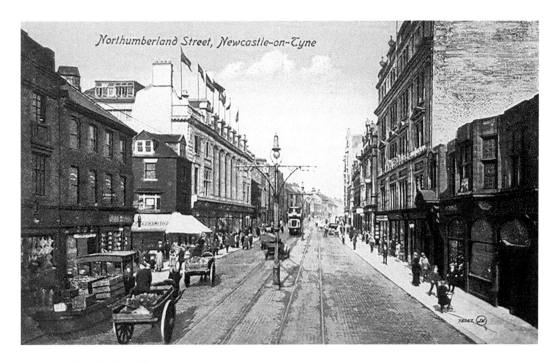

Northumberland Street

The street began as the continuation of Pilgrim Street, beyond the town wall, and was the main route into Northumberland. The images are looking northerly from the junction with Pilgrim Street and New Bridge Street. Both images show the Fenwick department store on the left centre, which was founded in 1882 by John James Fenwick. Note also the Pearl Assurance Building and Cooks tourist office shown bottom right on the image below. The images are looking northerly from the junction with Pilgrim Street and New Bridge Street. The street is approximately 0.25 miles long.

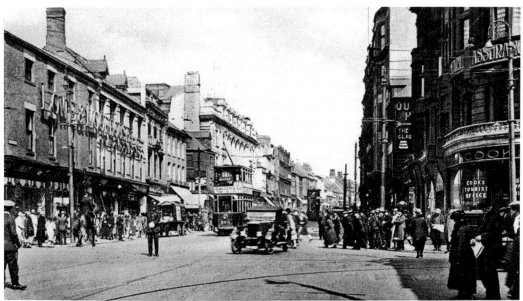

NORTHUMBERLAND STREET, NEWCASTLE-ON-TYNE

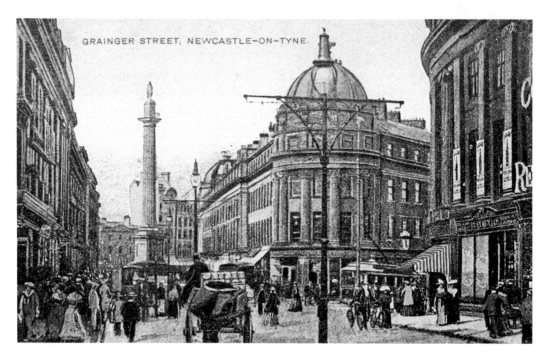

GRAINGER STREET, NEWCASTLE-ON-TYNE.

Grainger Street

The street is approximately 0.36 miles long and runs in a north-easterly direction between Neville Street and Blackett Street. The street was named after Richard Grainger and built as part of his redevelopment of the city centre between 1824 and 1841. These images are looking north-easterly from near the junction with Nun Street and show the Central Market, with the domed tower, at the junction of Market Street.

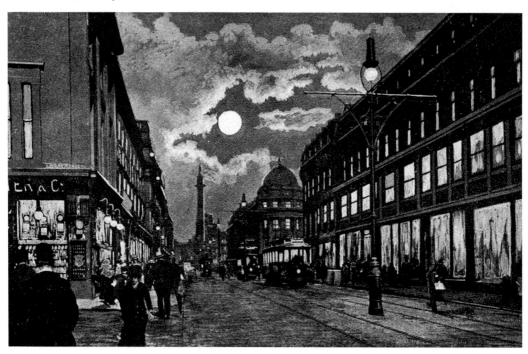

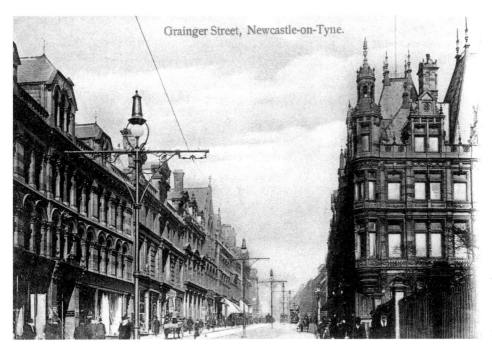

Grainger Street, Newcastle-on-Tyne.

1088. 3

Grainger Street

These images are looking north-easterly and taken from outside St John's Church on the right where the railings of the church can be seen. Grey's Monument can just be seen in the centre background. Note the trams and the horse and carts.

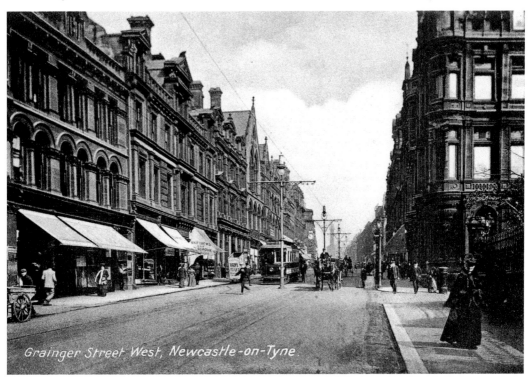

Grainger Street West, Newcastle-on-Tyne

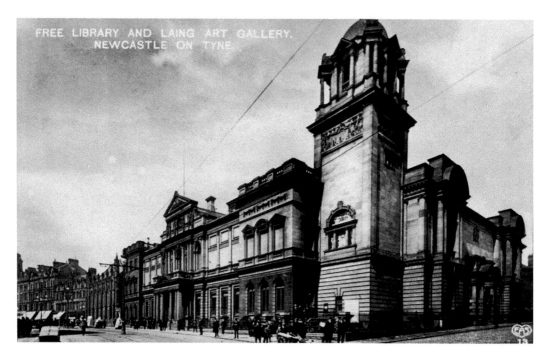

FREE LIBRARY AND LAING ART GALLERY.
NEWCASTLE ON TYNE.

Central Library

Building of the Free Library, later known as Central Library, on New Bridge Street began in 1881 and the medieval Carliol Tower was demolished to make way for it. In turn the library building was demolished in 1967 to make way for the building of John Dobson Street.

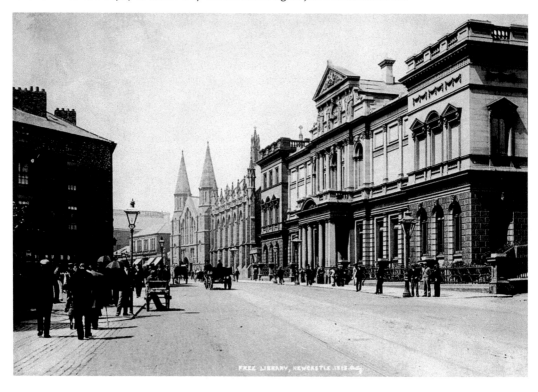

FREE LIBRARY, NEWCASTLE .1913.

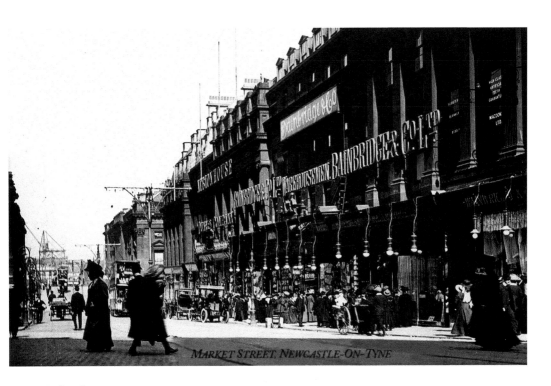

MARKET STREET, NEWCASTLE-ON-TYNE

Market Street

This street was part of the nineteenth-century Grainger development and at the time ran between Grainger Street and New Bridge Street. It is approximately 0.32 miles long. The images are taken looking along the street in an easterly direction from its junction with Grainger Street. Note the Bainbridge & Co. Ltd store on the right of both images and the dome of the Central Arcade on the left of the image below.

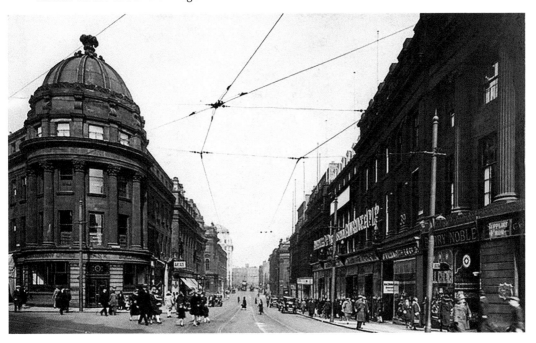

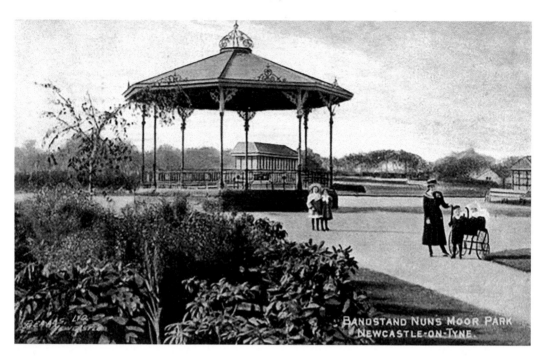

Nuns Moor Park

The Nuns Moor belonged to the nuns of St Bartholomew and after the dissolution it was sold on and eventually acquired by the corporation of Newcastle in 1653. It was established in the Victorian era as a park used mainly for leisure activities for the local community. It originally had three bowling greens and a space dedicated to playing quoits, as well as a popular bandstand. The above image shows the bandstand and the one below the entrance lodge at the junction of Studley Terrace and Brighton Grove.

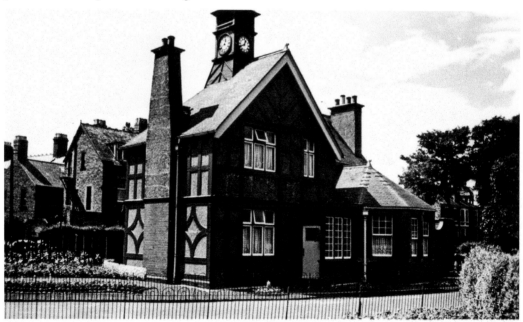

NUNS MOOR PARK. FENHAM.

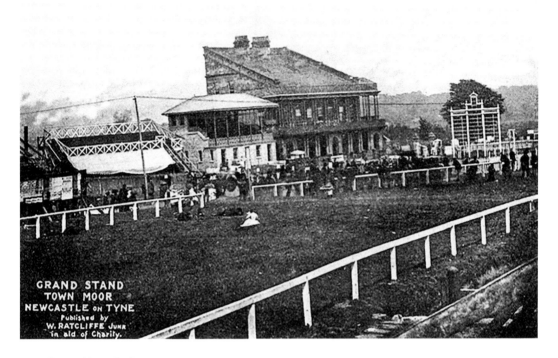

GRAND STAND
TOWN MOOR
NEWCASTLE on TYNE
Published by
W. RATCLIFFE Junr
in aid of Charity.

Town Moor Park

The Town Moor is around 990 acres of open space at the north of the city centre. From 1833 the Northumberland Plate horse race was hosted at the Town Moor but by the summer of 1881 the Town Moor hosted its last race and racing moved to Gosforth Park that same year. A Smallpox Isolation Hospital was built on the moor and opened in 1882. It comprised a single enclosure divided into two units, one with seventy-two beds and the other being an isolation section with 100 beds.

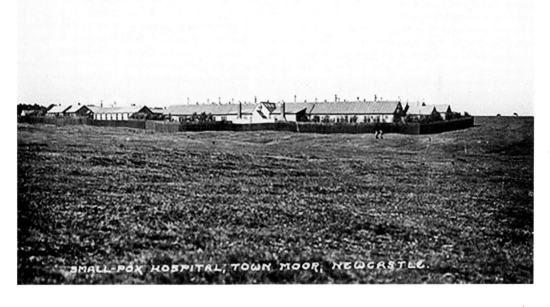

SMALL-POX HOSPITAL, TOWN MOOR, NEWCASTLE.

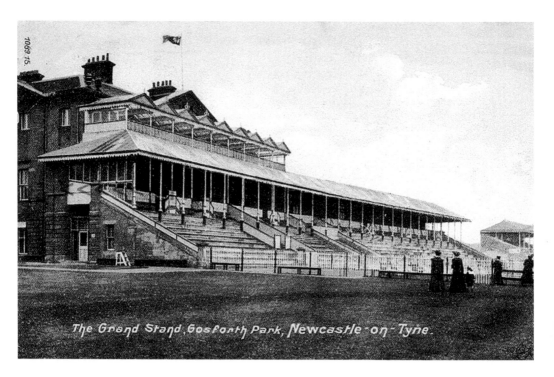

The Grand Stand, Gosforth Park, Newcastle-on-Tyne.

Gosforth Park

The 812-acre park was laid out by Charles Brandling (1733–1802), who was a wealthy coal mine owner and local politician. His new mansion, Gosforth House, was built there between 1755 and 1764. When racing was moved from Town Moor in 1881, a grandstand was then built in front of the mansion as shown on the two images.

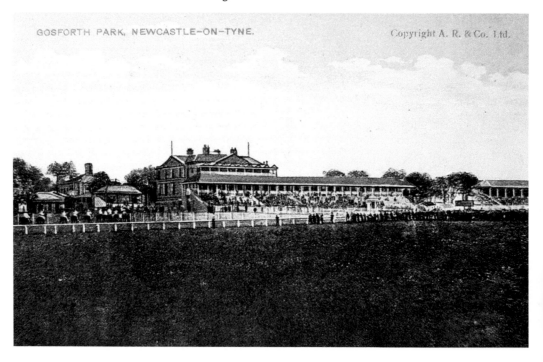

GOSFORTH PARK, NEWCASTLE-ON-TYNE. Copyright A. R. & Co. Ltd.

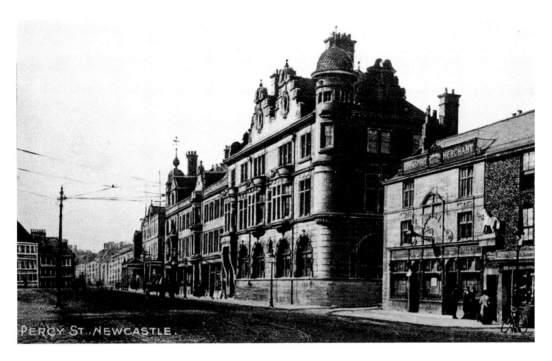

Percy Street

The street runs south-west from the Haymarket and Barras Bridge to Newgate Street, at the junction with Gallowgate and Blackett Street. It is approximately 0.29 miles long. The images are taken from the Haymarket looking south-westerly across to George Place and show the Bruce Building, which was designed by architect Joseph Oswald and was built as the headquarters of Newcastle Breweries.

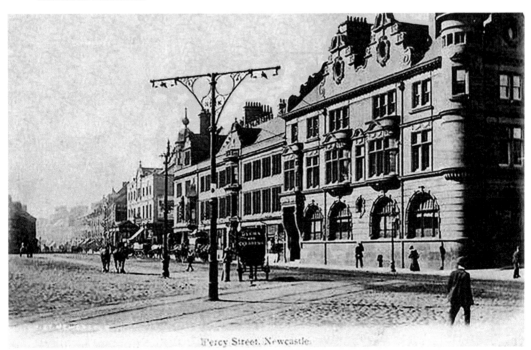

Percy Street, Newcastle.

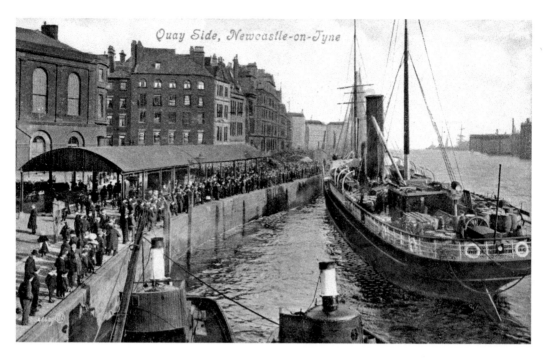

Quayside

The area, which has medieval origins, was once industrial with a busy commercial dockside. For centuries the Quayside was a home to sea merchants, hostmen and members of related trades. The Quayside also hosted a regular street market, which has a long history dating back to 1736 when it was first recorded in historic records as a fair. The images are looking east towards Sandgate.

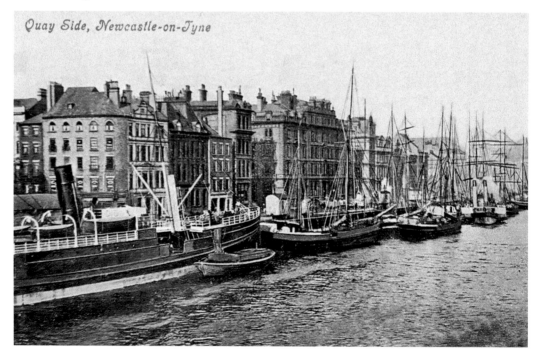

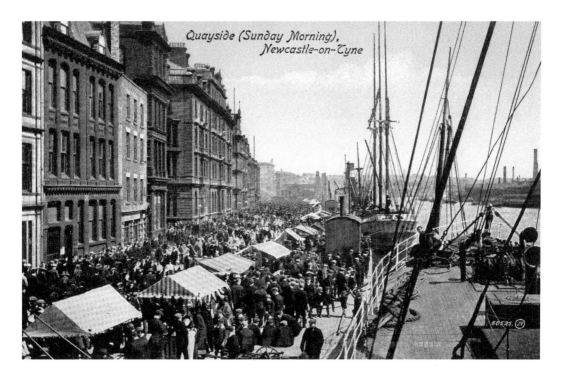

Quayside (Sunday Morning), Newcastle-on-Tyne

Quayside

The original Quayside market stretched from the old Tyne Bridge, near the site of the current Swing Bridge, along Sandgate and beyond. Commercial stalls selling every manner of goods were pitched along the riverside with a variety of fairground attractions and racing tipsters providing added entertainment. The above image is looking east and the bottom image looking west, with the High Level and Swing Bridges visible in the background.

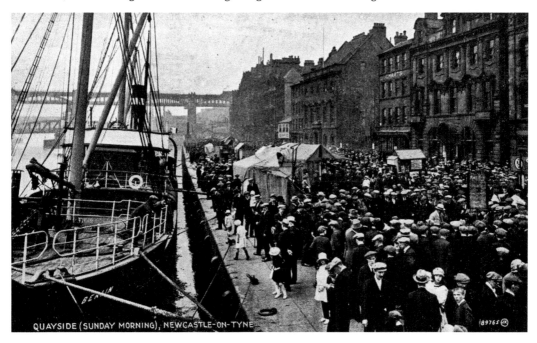

QUAYSIDE (SUNDAY MORNING), NEWCASTLE-ON-TYNE

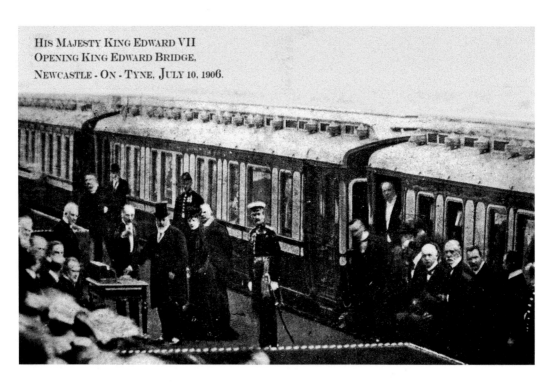

HIS MAJESTY KING EDWARD VII
OPENING KING EDWARD BRIDGE,
NEWCASTLE - ON - TYNE, JULY 10, 1906.

Royal Visit, 1906

On 10 July 1906 King Edward VII and Queen Alexandra opened the rail bridge over the Tyne, which was named after the king. The image above shows the opening ceremony and the image below shows the royal carriage making its way through the streets the following day for two more opening ceremonies.

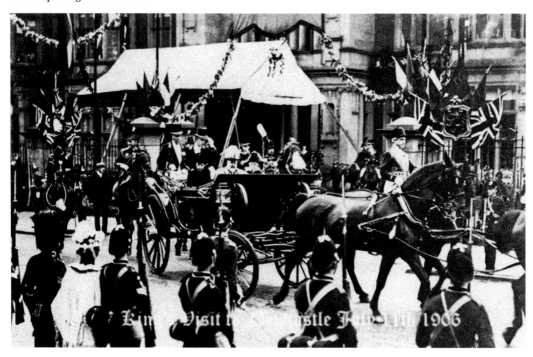

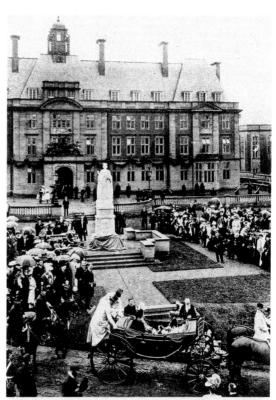

Royal Visit, 1906

On 11 July 1908, King Edward VII opened the Royal Victoria Infirmary by unveiling a statue of a young Queen Victoria as shown on the top image. The image below shows the crowds outside the Armstrong College, which was also officially opened by the king on the same day.

Unveiling Victoria Statue, Royal Victoria Infirmary 1906

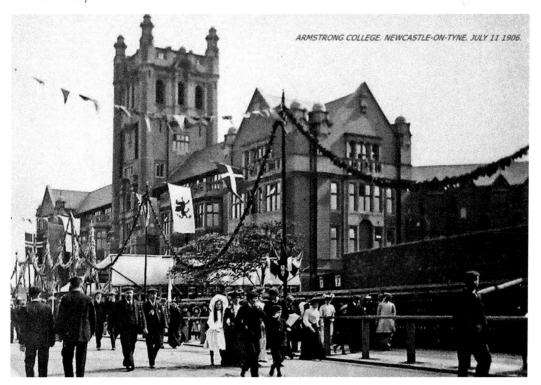

ARMSTRONG COLLEGE. NEWCASTLE-ON-TYNE. JULY 11 1906.

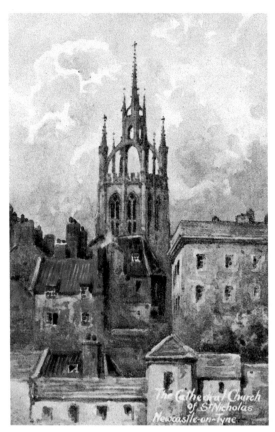

The Cathedral Church
of St Nicholas
Newcastle-on-Tyne

St Nicholas' Cathedral

Named after St Nicholas as patron saint of sailors and voyagers, the cathedral was long used as a navigation point for sailors on the Tyne. It is located at the junction of Mosely Street and St Nicholas Street. The tower is 196.5 feet high from the base to the top of the steeple.

The parish church of St Nicholas was predominantly built in the fourteenth and fifteenth centuries and has an impressive tower that is noted for its lantern spire, which was constructed in 1448. The building was extensively restored in 1777 and was raised to cathedral status in 1882, when it became known as the Cathedral Church of St Nicholas.

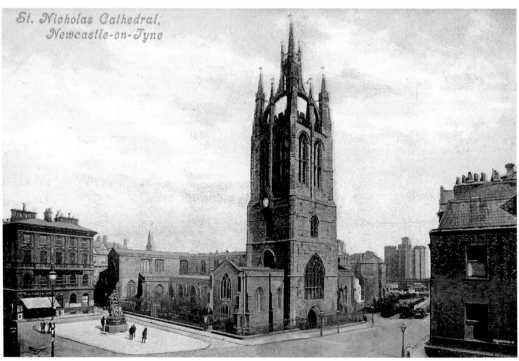

St. Nicholas Cathedral,
Newcastle-on-Tyne

St Nicholas' Cathedral

The top image is taken from the nave and shows the rood screen carved by Ralph Hedley in the late 1880s. The rood screen is also called the choir screen or chancel screen. It is a common feature in late medieval church architecture. The image below shows the chancel and reredos beyond the rood screen. The reredos is an ornamental screen covering the wall at the back of an altar. The chancel is near the altar and reserved for the clergy and choir. The work was completed in 1887.

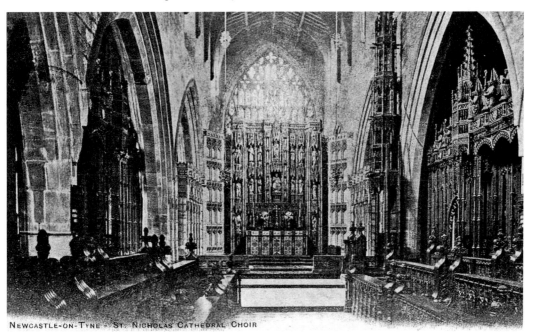

St. Nicholas Cathedral, Newcastle-on-Tyne.

NEWCASTLE-ON-TYNE · ST. NICHOLAS CATHEDRAL CHOIR

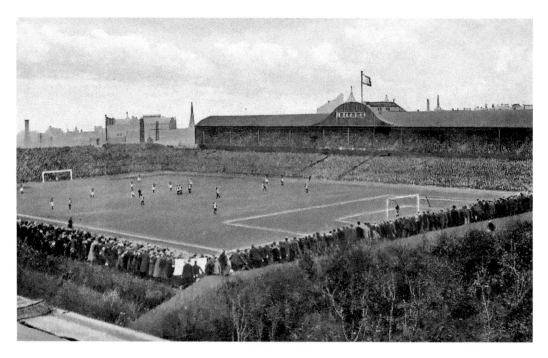

St James' Park

Historically, a hospital and chapel named St James' stood near to the site. St. James Place was later built on the site and the area continued to develop to where the football ground now stands. At either end of the ground are the Leazes End, named after the neighbouring Leazes Park and the Gallowgate End named after the city's infamous gallows, which were last used in 1844. The clubs Newcastle East End and West End FC merged and formally took up residence at St James' Park in 1892, becoming Newcastle United. The above image is looking from the north-east corner and the one below is looking north with the West Stand on the left and the Leazes End terrace roof shown at the far end of the ground.

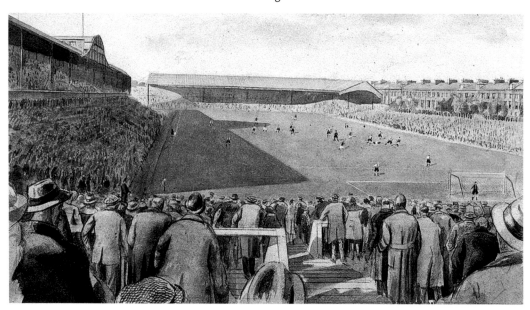

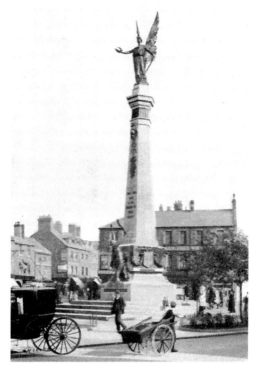

South African War Memorial

The memorial stands at the junction of Percy Street and St Mary's Place and is dedicated to those in the Northumbrian Regiments who died in the South African conflict between 1899 and 1902. The memorial is 79 feet high. The statue on top of the column is of the Greek goddess of Victory.

The monument was designed by Thomas Eyre Macklin, constructed in 1907 and unveiled in 1908. The bronze Victory sits on a hexagonal ashlar obelisk. Around the base are copper panels with bronze shields listing the names of the fallen.

The top image shows Haymarket to the right and the top of Northumberland Street to the left. The bottom image shows Northumberland Street to the right and St Mary's Place to the left. The tower of St James' Church can be seen.

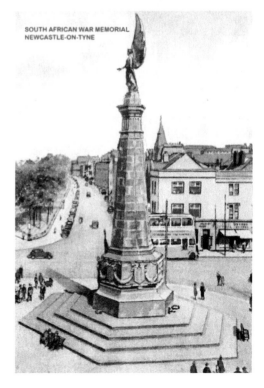

SOUTH AFRICAN WAR MEMORIAL
NEWCASTLE-ON-TYNE

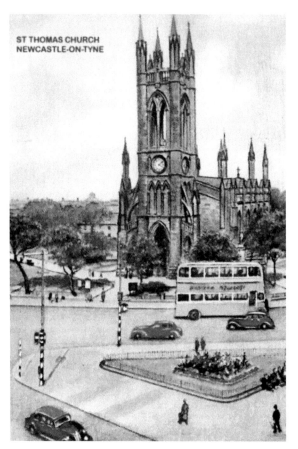

ST THOMAS CHURCH
NEWCASTLE-ON-TYNE

St Thomas' Church

St Thomas' Church is located at the junction of Barras Bridge and St Mary's Place. The present church was built between 1827 and 1830 in Victorian Gothic style by the architect John Dobson.

The top image is looking from the top of Percy Street with Barras Bridge and Northumberland Street in front of the church. The bottom image is looking south showing the Renwick, or Response, Memorial in the church grounds. The South African War memorial can be seen to the right.

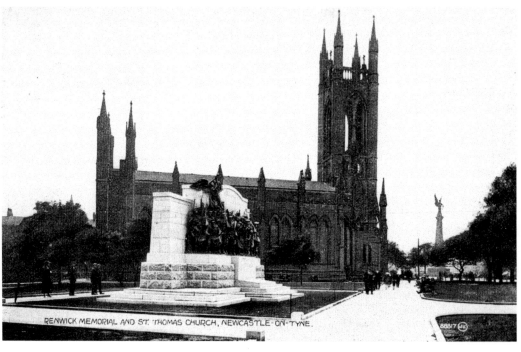

RENWICK MEMORIAL AND ST. THOMAS CHURCH, NEWCASTLE-ON-TYNE.

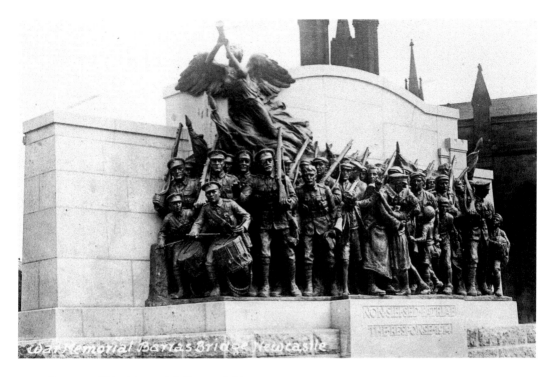

Response War Memorial, Barras Bridge

The Northumberland Fusiliers Memorial 'the Response' is a war memorial in the public gardens to the north of the Church of St Thomas the Martyr in Barras Bridge. The memorial was designed by Sir W. Goscombe John, commissioned by Sir George Renwick and was unveiled by the Prince of Wales on 5 July 1923.

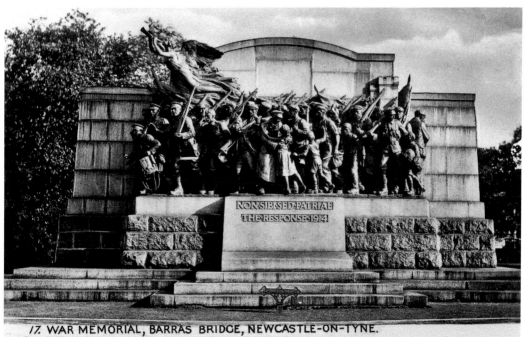

17. WAR MEMORIAL, BARRAS BRIDGE, NEWCASTLE-ON-TYNE.

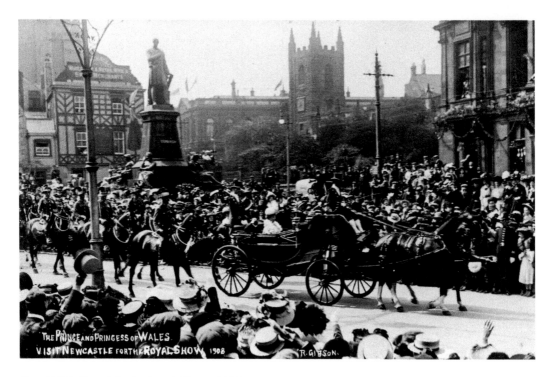

Royal Visit, Royal Agricultural Show, 1908

Large crowds welcomed the Prince and Princess of Wales when they arrived on Monday afternoon on 29 June 1908. The above image shows the royal party en route to Alnwick, where they stayed with the Duke and Duchess of Northumberland. The Prince and Princess of Wales twice visited the Royal Agricultural Show on the following Wednesday and Friday. The image below shows the showground on Town Moor.

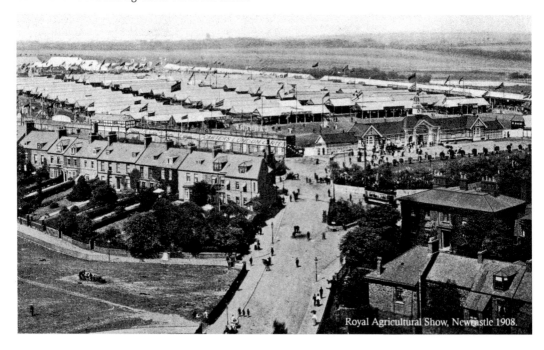

Royal Agricultural Show, Newcastle 1908.

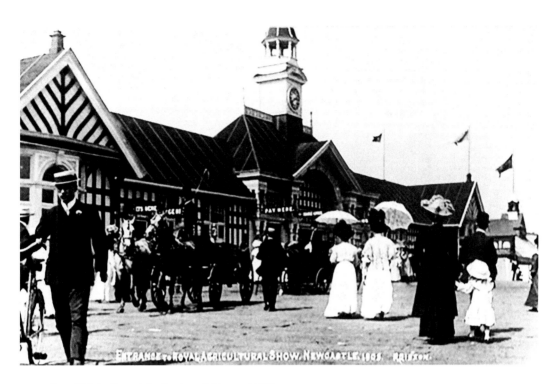

Royal Visit, Royal Agricultural Show, 1908

The above image shows the entrance to the show, which was on Park Terrace, and the one below shows the Royal Pavilion. The sixty-ninth annual Royal Agricultural Society show began on Tuesday 30 June 1908 and was open for four days. There were around forty exhibitors of motor vehicles or tractors for use on the farm or for hauling and contracting work. The image below shows the Royal Pavilion within the grounds of the show.

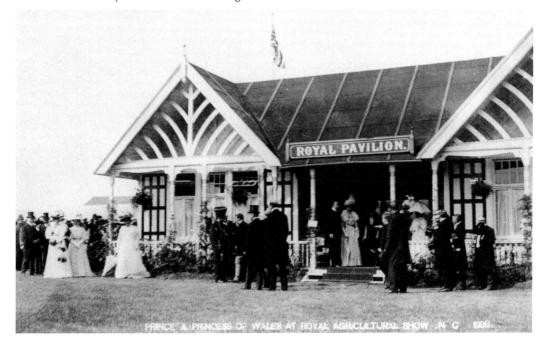

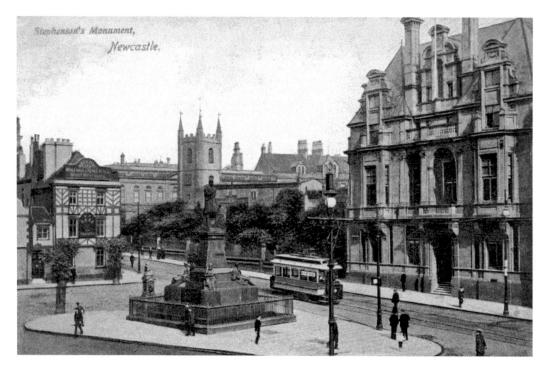

Stephenson's Monument

This monument to the eminent civil and mechanical engineer George Stephenson is located on the junction of Westgate Road and Neville Street. The monument was designed by John Graham Lough and unveiled in a ceremony on 2 October 1862. Below the main bronze statue of George Stephenson and on the corners of the sandstone plinth are four further statues of Stephenson, representing the areas of his achievements as a miner, a locomotive engineer, a blacksmith and a bridge builder.

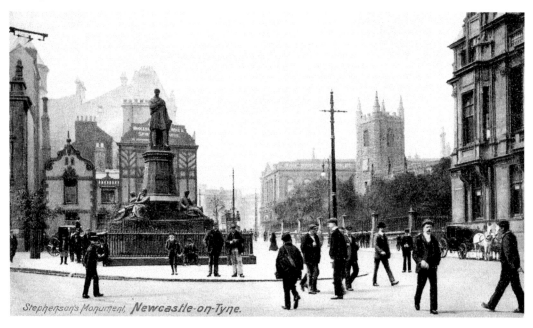

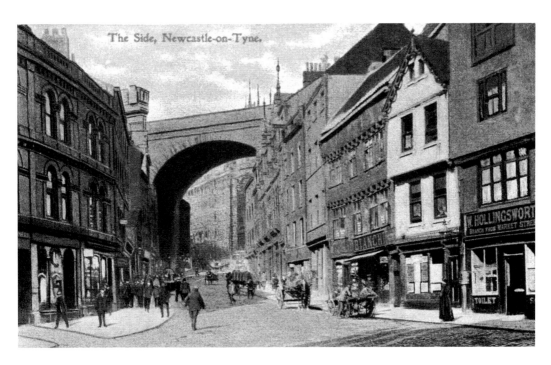

The Side, Newcastle-on-Tyne.

The Side

This street runs from St Nicholas Street to the junction of Sandhill and Queen Street. It is approximately 0.16 miles long. The images are taken from the junction of Sandhill and Queen Street looking in a westerly direction. On the image above, the top of the lantern spire of St Nicholas' Cathedral can just be seen.

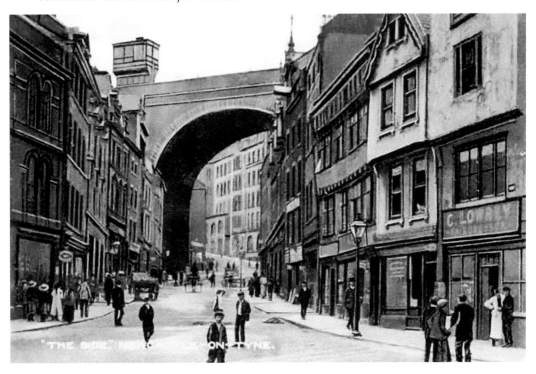

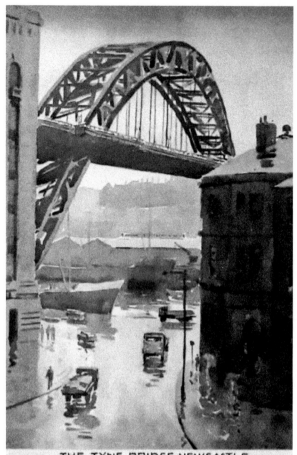

THE TYNE BRIDGE, NEWCASTLE

The Tyne Bridge

The bridge was designed by the engineering firm Mott, Hay and Anderson and was built by Dorman Long & Co. of Middlesbrough. The bridge was officially opened on 10 October 1928 by King George V.

The bridge spans 532 feet and has a height of 164 feet. The Tyne Bridge was built with 7,000 tons of steel. The bridge was built with rivets and panels that were welded together. The bridge is a single span structure so as not to obstruct river traffic.

Perched over 80 feet above the river, the men worked without the benefit of safety harnesses and ropes. Their agility and ability to work at great heights was second to none. Despite the dangers only one worker, a scaffold erecter, died when he fell a hundred feet from the bridge into the water.

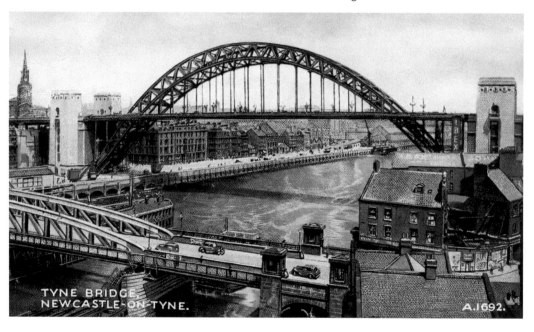

TYNE BRIDGE,
NEWCASTLE-ON-TYNE.

A.1692.

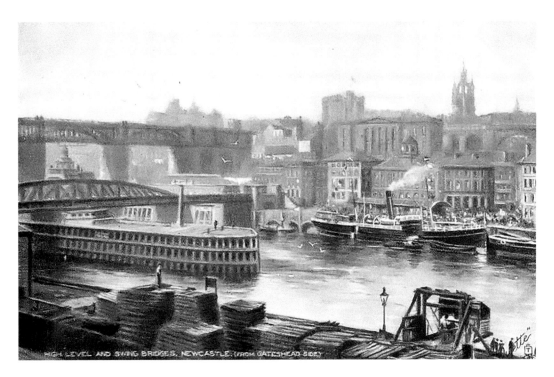

HIGH LEVEL AND SWING BRIDGES, NEWCASTLE. (FROM GATESHEAD SIDE)

The High Level and Swing Bridges

Opened in 1849, the High Level Bridge at Newcastle was part of the objective to create a continuous rail line from London to Edinburgh, and it was designed by Robert Stephenson. The hydraulic Swing Bridge was designed and paid for by Lord Armstrong, with work beginning in 1873. It was first used for road traffic on 15 June 1876 and opened for river traffic on 17 July 1876.

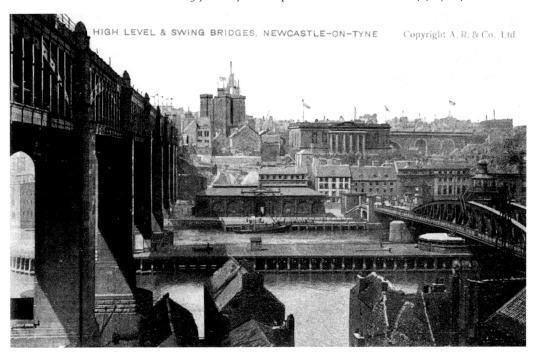

HIGH LEVEL & SWING BRIDGES, NEWCASTLE-ON-TYNE Copyright A. R. & Co. Ltd

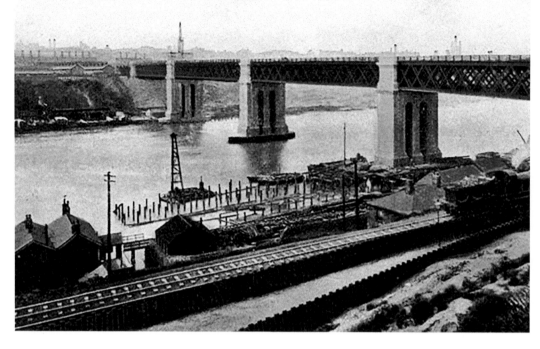

The King Edward VII Bridge

Construction began in July 1902, and the bridge was opened by King Edward VII and Queen Alexandra on 10 July 1906. It consists of four lattice steel spans resting on substantial concrete piers. The total length of the bridge is 1,150 feet.

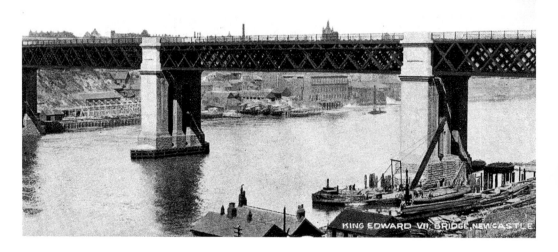

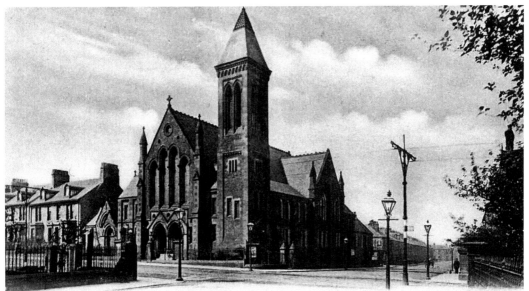

Bainbridge Memorial Chapel, Heaton Road, Newcastle-on-Tyne Valentine's Series

H. Denholm Brash, Bookseller and Stationer, Newcastle-on-Tyne

Bainbridge Memorial Chapel

The origins of the Bainbridge Memorial Church lie in a Wesleyan chapel erected in the St Lawrence area of Newcastle in 1839. The membership of the society increased rapidly and it soon became clear that a larger church would be needed. A new church building was built on Heaton Road and was opened on 25 November 1885, retaining the old name of Cuthbert Bainbridge Memorial. The above image shows the chapel on the corner of Heaton Road and Tynemouth Road. The image below is looking north along Heaton Road with the chapel on the left and the Congregational church on the right.

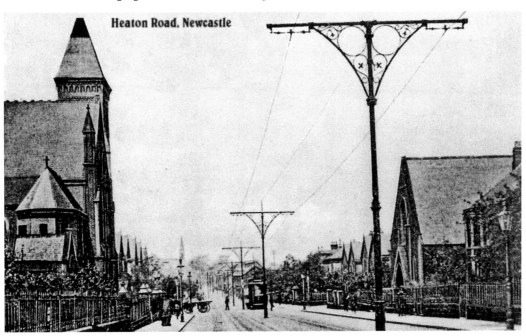

Heaton Road, Newcastle

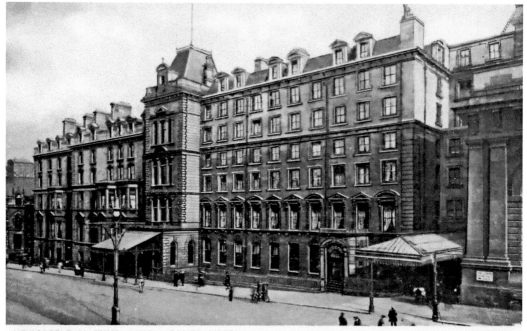

NEWCASTLE-ON-TYNE. ROYAL STATION HOTEL H 139/15

Royal Station Hotel

The hotel was designed by John Dobson, and the first ten bays were built between 1847 and 1850. The hotel was extended in 1891. The hotel is situated next to the Central station on Neville Street. The hotel was formally opened by Queen Victoria on 29 August 1850 when at the same time she opened the station. The above image shows the façade and the one below the Drawing Room in 1913.

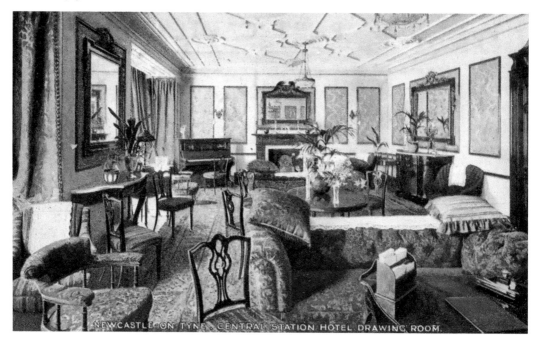

NEWCASTLE-ON-TYNE. CENTRAL STATION HOTEL DRAWING ROOM.

Douglas Hotel

The hotel began trading in 1877 as a fifty-bedroom hotel and was designed by Tyneside-based architect John Edward Watson. The hotel is at the junction of Neville Street and Grainger Street. The entrance to the hotel is on Grainger Street. In the background on the image below the tower of St John's Church can be seen. In the foreground a No. 7 trolley bus can be seen approaching the junction with Neville Street.

The Douglas Hotel, Newcastle-on-Tyne.

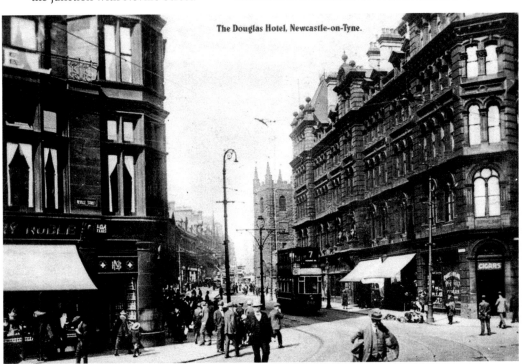

The Douglas Hotel, Newcastle-on-Tyne.

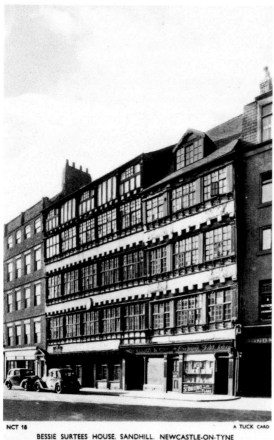

BESSIE SURTEES HOUSE. SANDHILL. NEWCASTLE-ON-TYNE

Bessie Surtees House
The building is named after Bessie
Surtees, who in 1772 climbed down
from the first-floor window and
eloped to Scotland with John Scott, a
coal merchant's son. John Scott later
became Lord Eldon, Lord Chancellor of
England.

The building used to be two separate
merchant's houses known as Surtees
House and Milbank House, which were
built in the sixteenth and seventeenth
centuries. The building is located near
the riverfront on Sandhill.

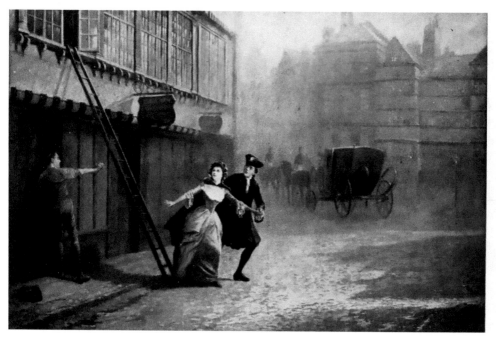

THE ELOPEMENT OF BESSY SURTEES WITH JOHN SCOTT. 1772
From the painting by Wilson Hepple.

92

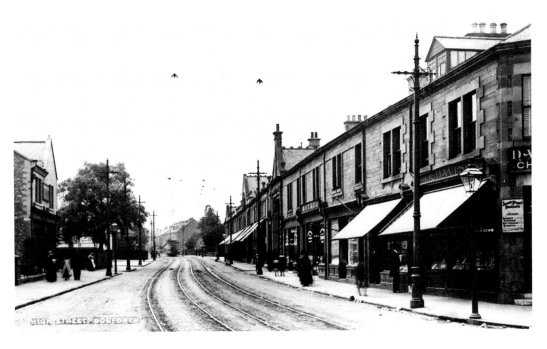

Gosforth High Street

The High Street is part of the Great North Road in the area that began in 1826 as a settlement known for several decades as Bulman Village. The street is approximately 0.82 miles long and runs from Moorfield in the south to Christon Road in the north. The images are taken just north of Causey Street, with the junction of Hawthorn Road off to the left. Note the No. 8 tram with its destination marked as Central.

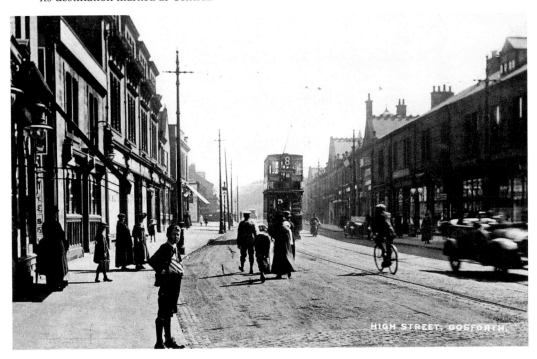

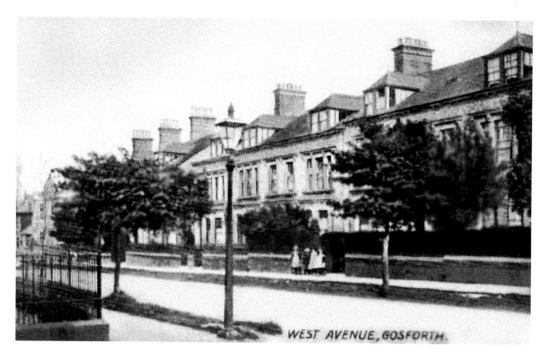

WEST AVENUE, GOSFORTH.

Gosforth West Avenue

The avenue runs from the High Street to Linden Road and is approximately 0.17 miles long. The above image is looking south-easterly from the junction with Woodbine Avenue. The bottom image is looking westerly with the square tower of All Saints Church shown, which is at the junction with Linden Road. Also in the image below note, in the left foreground, the start of an alley, ginnel or snicket that runs behind the back of the properties.

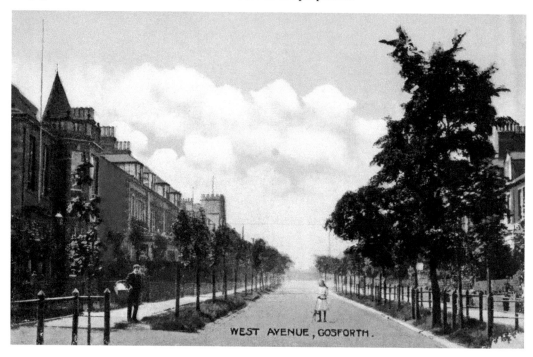

WEST AVENUE, GOSFORTH.

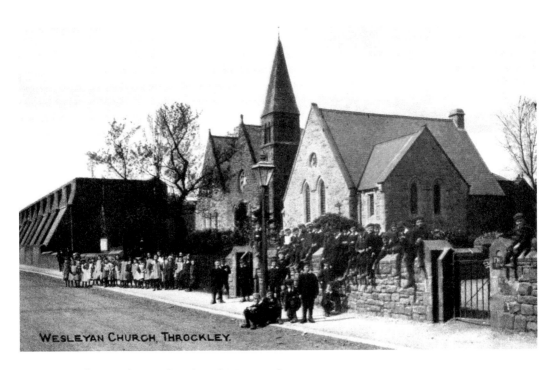

WESLEYAN CHURCH, THROCKLEY.

Throckley Wesleyan Church and Waterworks

The buildings are situated in Hexham Road. The images show the church in the centre with the church hall to the right of it and the Water Company Reservoir to the left. The Wesleyan Methodist Church was built in 1871, and the church hall in 1905. The water treatment works with extensive filter beds were completed in 1875 for the Newcastle and Gateshead Water Company,

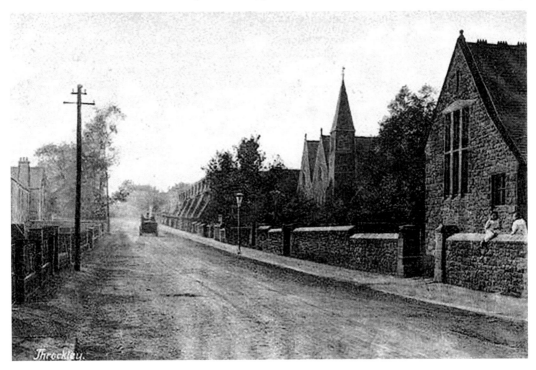

Throckley.

SOURCES

The following in particular have been a good source of information for the captions to the images:

Newcastle Chronicle
Newcastle University
Historic England
Newcastle City Council

The following have been used a number of times to determine the location of where the image was taken from:

Google Earth
National Library of Scotland Side by Side Referenced Maps

ABOUT THE AUTHOR

Alan Spree BSc CEng MICE MCIHT was born in Nottingham in 1944 and was educated at Glaisdale Bilateral School in Bilborough. He moved to Portsmouth with his family in 1959 and completed his secondary education at Eastney Modern School. He took an apprenticeship as a bricklayer in Portsmouth Dockyard and as part of that he received further education at Highbury Technical College. He then gained a degree in Civil Engineering at Portsmouth University before becoming a professionally qualified civil engineer. Alan worked with the Department of Environment at Portsmouth, Reading, London and Germany until voluntary retirement in 1998. He then worked for Berkshire County Council and Preston City Council before retirement to Spain in 2006.